ANDREW MARR

A short book about painting

quadrille

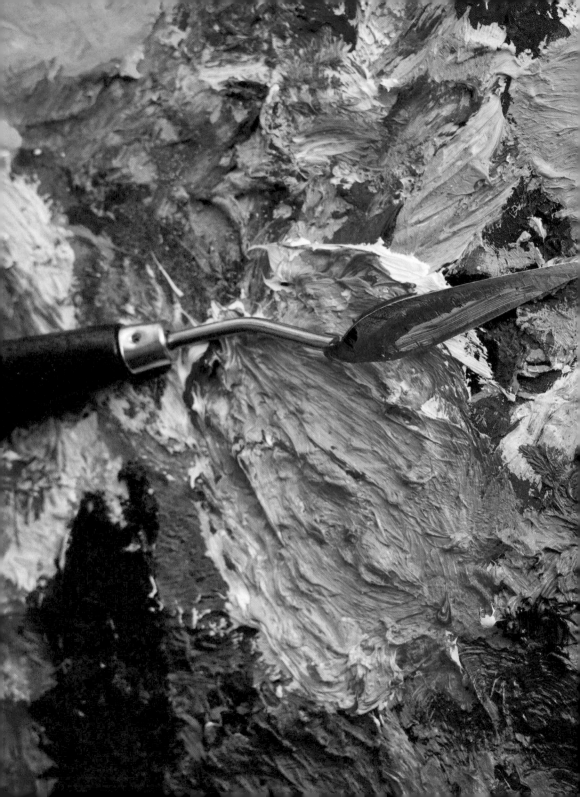

ANDREW MARR

A short book about painting

Publishing director: Sarah Lavelle
Creative director: Helen Lewis
Project editor: Jinny Johnson
Designer: Gemma Wilson
Picture researcher: Liz Boyd
Proofreader: Mary-Jane Wilkins
Production director: Vincent Smith
Production controller: Tom Moore

Jacket and photographs on pages 2–3, 5 and 7 © Andy Sewell
Photographs of Andrew Marr's paintings by A C Cooper Limited
Original design concept: Lawrence Morton

First published in 2017 by
Quadrille Publishing Ltd
Pentagon House
52-54 Southwark Street
London SE1 1UN
www.quadrille.com

Quadrille is an imprint of Hardie Grant
www.hardiegrant.com

CONTENTS

INTRODUCTION

*What is this book and who is it for? To begin with,
here is what it isn't: it isn't a painting primer, any
kind of manual or a "how-to" book. If that's what
you're after, there are hundreds to choose from.
Neither is it a book about the history of painting,
nor a collection of essays on art. Again, you may
have come across one or two of those already.*

*This is a book for people who enjoy looking at
paintings, and for people who paint. As someone
who does both, I realised that the problems of
looking at paintings – and I'm thinking mostly
about contemporary paintings – and making
paintings are intimately connected.*

Why do I like this picture? And why do I think that one's a failure? Why do some compositions hold attractively together, and others collapse? Why do I feel an emotional response to one combination of colours, while another leaves me cold?

Looking at modern painting is both popular and quite difficult. The exhibitions of modern masters swarm with art lovers, who have mostly paid for tickets and travel. If you look at their faces you will see concentrated, rapt expressions. Why, really, are they there? What do they want from the experience?

Whatever they're doing, they are making judgements about hard problems. They are making sense of canvases painted in a single colour, with no motifs; they may be engaging emotionally with entirely abstract shapes; they are responding to the material presence of something that's a long way away from being a photograph. And as they look, they are thinking about, and perhaps resolving, issues that practising painters struggle with every day.

My only advantage in writing about all this is that because I paint, I can talk about colour, composition, ambition and failure without libelling anybody else. I hope I can get close to the mystery of what happens in the studio when a painter is thinking about what to do – though I don't think I have resolved that mystery. In general, when it

A SHORT BOOK ABOUT PAINTING

comes to painting, we talk perhaps too easily and triumphantly about success and we don't think enough about the failures from which lessons are learned and on which success is built.

I have structured this short book as follows: after an introductory chapter which dives straight into questions about what painting, or indeed any art, is for, I deal with changing taste; with colour; and with the problem of shape, or motif. I then try to describe what happens in the studio, and the materials art is made from and why they matter. On the way, I express heartfelt hostility to aspects of the art market and contemporary taste.

So this is a book about the most enjoyable, difficult, serious thing I have so far found to spend time on. If it makes you look at pictures even slightly differently, or if it encourages you in the making of your own pictures, then it will have done its job.

Andrew Marr, *Primrose Hill, March 2017*

1 LOSING MY RELIGION

What is painting for?

Our time in this world is very beautiful, and very brief. To properly grasp this, every day, we need perspective, a view of it. The appropriate word is *transcendence*, meaning to climb above, or climb out of, the everyday. Up there, reflecting, we may be better able to appreciate the world's beauty and its brevity.

Transcendence is what we hope for from art whether it be through the slow movement of a Beethoven string quartet, a soliloquy in a Samuel Beckett play, or the shapes and colours of a late Matisse. These are simply different routes – different fixes, different needles – to achieve the same end, which is, I repeat, a better perspective on this

business of being alive. Most of the time in day-to-day life there is no such perspective. And in trying to discover it, much art fails.

Our world is beautiful; but also very boring. I am writing this in Florida, once an untamed tract of mangroves and marshy rainforest, full of wildness and surprising beauty, but now a huge, bleak grid of turnpikes and motorways, endlessly scored across with lines of concrete and wire. Unlovely barrack-like buildings and a tangle of advertising signs offer a rare splash of colour. The roads are congested; as cars dawdle alongside you, you see angry and frustrated faces flinching at the red lights ahead. Everybody is on the move. Everybody, it seems, is anxious to be somewhere else. Time is sliced into harried segments.

That is one person's impression of life in one place, but there is a more general point. Almost wherever we are, our experience of life is often of boredom and frustration. We are glued into time, the fourth dimension, and yet there is never nearly enough of it. And this, for me, is the point of art. Art helps us to stop off and remind ourselves that we are making but a brief visit to a beautiful world. Remembering this regularly is probably a way to be happy.

Painting is a system of communication with only one message, the sensation of being alive more intensely than normal.

Some people will say this is not true. Or at least, not completely true. And yes, painting can be

sardonic, sarcastic, ironic – many things. And yes, we live in a profoundly sarcastic, ironic and even cruel culture. The inaptly described "social media" produces a vortex of fear, mockery and hatred. More of our films are about violence and destruction than any other subject. Our mainstream media relates a ceaseless narrative of failure and greed, disaster and cowardice. I'm part of it; I hate that. And some paintings, like many pieces of music, theatrical performances and other art forms, fall woefully short: they add to the general boredom.

But of course we are much more interesting than this, and we know it, at least some of the time. We want to climb out of the grey filth; we are desperate for transcendence.

Many people achieve transcendence through religion or a quasi-religious practice – prayer, meditation, praise. But religion's rival for transcendence, for a better perspective on the brief and surprising glory of being alive, is art.

Looking or listening?

If that is true, how does visual art differ from, for instance, the arts of poetry or music? Is the difference trivial or fundamental? These are questions not just for those who make art but also for all of us who experience it. And there is no doubt that the materials or forms used to create an artwork affect its possibilities. A poem, composed of words, necessarily involves different parts of the brain from a painting. The poem carries with it the

whole complex history and structure of daily language, echoes, expectations, and the underlying logic of syntax. The mind is scurrying to make sense, even as it is being seduced by the music. A successful poem might be said to occur at the point when the reader ceases to be aware of the words as words, and the poem appears to become life itself. But a poem that tries to leave behind the literal meaning of the packets of syllables, their everyday significance, generally falls into obscurity and fails.

Music, originating deep in our prehistoric past, and fired by the human need for communal movement and rhythm, works differently. It has its logic, of course, and its highly sophisticated language, which can be written out just like English, German or Mandarin. But it stands further away from mundane communication. It works by seducing our natural love for harmonies and regular rhythms, and then overturning or subverting our expectations – thus time is given added drama.

To enjoy a poem or a piece of good music you need to concentrate while emptying your mind of the surrounding clutter. If you are thinking about the school pickup, or an unpaid bill, you aren't going to be pulled in by T S Eliot or by Beethoven. You are going to get your transcendence – you're going to climb that ladder and look at life afresh – only if you focus hard on the lines or the sounds.

In a poem, that most intense and unstable of art forms, we naturally enjoy assonance, wit and rhythm, as we follow the logic of the words. In a

piece of music, we seem to have a natural liking
for certain harmonies, and we yearn for harmonic
resolution even as we enjoy being wrong-footed. In
painting, certain shapes and colour combinations
mean a great deal to us, probably because of our
evolutionary history – more on this later. Yellows
and blues, greens and reds, sit naturally together.
A horizontal horizon line, particularly if we are
looking down at it towards the bottom of the picture
frame, brings a feeling of calm and security. Slanted
lines, particularly zigzags, produce disquiet. A range
of soft to aquamarine blues, redolent of a warm
sky, appeal to almost everyone. And as in music or
poetry, we look for harmony and balance – we like
shapes to be echoed, though not monotonously,
and we expect the energy of the picture to be
resolved inside it, not to fly off on to the wall
over one side or another.

In all of the arts, we understand when they
are having an impact on us, physically. Our blood
pressure rises. We breathe slightly faster and more
deeply. And we feel a nervous concentration that
isn't sexual (far from it) and yet is parallel. These
are the bodily evidences of the better perspective
on life that we are looking for.

The deal; and a little autobiography
But in all the arts, this only happens through a
contract between the artist and the reader, listener or
watcher. It's a two-way deal. If you aren't open to the
experience, it won't come to you. The problem with

painting is that it can be glanced at. You don't buy a ticket, and promise to stand looking for x amount of time. Just as you can skim a poem, not properly reading it, or half-hear a piece of music, treating it as muzak, so you can walk past a picture and get the impression that you've seen it, rather than *actually* seeing it. You need a lot of time, looking hard, before a painting really releases its energy and its message.

For around 40 years, from my early teenage years to the age of 53, I painted like this: I would take a small box or a grimy bag of tubes of gouache or oil paint, a foldaway easel and a pre-prepared board to a hillside or a flat rock or to the side of the road. Then I would sketch out roughly what I saw in front of me, and paint it in colours. I would do this when I had a holiday or over a few free days – not very often. Over time and not surprisingly I became slightly more skilled, learned a few tricks and became, therefore, more artful. Then I had a stroke, which paralysed the left-hand side of my body, and I had to give all that up.

I now recognise that I've been telling a deceitful story about what happened next. I've said that because of the practical difficulties of being unable to paint outside, I was forced to start again in a studio, where I could control my environment. There, I was obliged to find a new way of painting because I didn't want to do still lifes of flowers or oranges, or indeed nudes.

Though all of that is true enough, it leaves out the most important thing. After coming close to losing

my life, I had a more intense sense of how little time
I had left – the "shortness of life" thing, running
alongside the "beauty of life" thing. I realised that,
more than anything else, I'd always wanted to paint
well, but that I'd put it off because I was frightened
of not being good enough. Now I thought to myself:
Andrew, you're in danger of running out of time.
How would you feel if you found yourself too old
and simply too frail to paint – and you'd never tried,
not seriously? You'd never risked it?

I knew I would feel mightily hacked off – a
coward – miserable. So I told myself to *get on with it*.
Try to paint properly. That's what I have been doing,
and it isn't really much to do with physical disability.
And I have never enjoyed myself more.

Well, enjoyed? Sometimes, with my back aching
and after several hours of intense concentration,
I find myself weeping with frustration. Why don't
I have that innate understanding of shape and form
that Kandinsky had? Why, after years of trying, can't
I draw a single line with the honesty of Matisse?
There are no answers beyond the vagaries of
differently distributed human skills and characters.
But at least I know where the gaps are.

I had originally decided to call this book *How to
Paint Badly* because that is mostly what I do. And
indeed, I think that very many painters, maybe
most, paint badly and then rescue failed marks and
designs at the last minute, wresting the roses of
success from the ashes of disaster, like those white-
bearded scientists in *Chitty Chitty Bang Bang*. But

then I decided that, apart from giving every critic too easy an introductory paragraph, such a title would be fundamentally dishonest. It's a kind of joke, made against myself. It sounds offhand, maybe cynical. But for me, nothing here is a joke.

What do I mean by painting "well"? I don't, I hope, have exaggerated ideas of my own talent but I want to make pictures that express how deeply I feel about the world, and aren't simply copies of how other people feel. And I want to make images that are alive and self-confident enough to hold their place on a wall. This, I have found, is surprisingly difficult.

The market problem

One of the reasons it's difficult here and now is that painting is enclosed by a loud and distracting art market. The shapers of taste and price are dauntingly grand. In the normal way, you wouldn't want to rub up against them. You have them and their favoured artists on the one hand, and a mutinous, deeply sceptical public on the other. And nobody, it seems just now, much wants to use words like transcendence or beauty.

We must be more knowing, apparently. We should be less naive. The art market is, like most markets, fast and efficient – but it's also hard-boiled and cynical. Entrepreneurs, investors and their experts dominate it. A chilly knowingness prevails; artists are bullied and bribed into producing predictable chunks of value that can be easily sold on.

The artist and the dealer need a brand. But the brands also need to keep changing – for why else would people keep buying? To maintain high prices in the market, to keep the buyer and media interest hot, relentless innovation is needed. *Yesterday's* new idea is deader than dead. To dwell on what is over is fatal – pathetic. Nothing is more dangerous in the bustle and press of the contemporary art market than nostalgia. As in financial markets, smoking-hot news is the only currency.

Well, that's how things are in our accelerating world. The danger is that through this process, art becomes like everything else – as ugly, as cynical and as pointless as much of the rest of contemporary culture. Dull as a traffic jam. And yet art that's being made right now all around the world by relatively unknown people can still grab us by the throat and take us out of ourselves, overthrowing our petty egotism.

This process is hard won, however. Successful art engages the intellect as well as emotion. It makes us concentrate. It quickens our breathing. It sharpens our attention. It cleans our spectacles, and it teaches us new ways of concentrating. It is so powerful – so very powerful – that it is triumphantly surviving its own snobby, cynical globalised market.

I've called this chapter "Losing my Religion", the title of the famous REM song. Apparently, it's simply Texan slang for becoming infuriated – as in "losing it". But art is the nearest thing I have to a religion and I do fear losing it because of the

cynicism and condescension of the modern art world. If you talk to intelligent, thoughtful gallery owners, and indeed to some artists, you find plenty of people just as worried.

But I'm trying *not* to lose my religion. When I'm tired, when I'm lonely, when I'm despairing, I go into a gallery and see a picture for the first time, perhaps by a 20-year-old from round the corner, perhaps by a Venetian who has been dead for four centuries, and I come alive again.

Dead art and alive art: yet another problem
Making "alive" art is hard even for the hugely talented and the closely observant. A painting by a famous and gifted artist, who has given it all his attention and accumulated skill, can suddenly, and dramatically, lose its life. It can become just another sticky "thing" rather than something that urgently communicates. I want to use this short book to try to explain what seems to me to be the key problem: what separates a dead failure from a living and inspiring artwork? This is something that confronts us surprisingly often.

Think of going into a chain hotel in any big city. There will be pictures, probably prints, scattered along the corridors and in the bedrooms. They will have been made by trained artists, who will have sold the rights to the images to the corporation that owns the hotel. These artists will be serious and perhaps committed people, certainly not cynical: and yet, 99 times out of a hundred, the art on the

walls will be dead. You will walk past it and you will feel entirely unchanged. Go into a big department store and you will find, in the bedroom furniture department, glossy, gold-leafed modern art works guaranteed to make you feel bored. Click on one of the popular image-based websites such as Pinterest, and you will quickly find more of the same.

And the point is that these are nearly quite good pictures. The gap between an abstract painting by Mark Rothko, which should bring you to the edge of tears, and a picture by one of his hundreds of talented imitators, which will bring you only tears of ennui, is a very tiny, thin and hard-to-describe line.

To complicate things further, plenty of dead art is made by famous and expensive artists. Jeff Koons is about as lauded as it gets. He specialises in fabricated sculptures of wood, steel or porcelain, on the most banal of subjects; they're a kind of running critique, presumably, of our trivial and commercialised world. But as commerce, they certainly work. In 2013 one of his "balloon dog" sculptures was sold by Christie's in New York for US$58.4 million, becoming the most expensive work by a living artist sold at auction.

Koons's work is knowing and glossy. Much of it is fabricated by others. If it is meant satirically, then nobody loves it more than the materialist super-rich at whom it is presumably aimed. (In which case, you might say, the aiming isn't so good.) For me, at least, it is utterly dead – banal and closer to appeasement than satire.

Genuinely alive art – whether it's a quick sketch of a mineral water bottle by David Hockney, or an assemblage of leaves pinned together with thorns by an environmental artist – depends first of all upon fresh looking. The artist may well be aware of the hundreds and thousands of years of art-making, but will have resisted the temptation to look at the world through spectacles borrowed from the dead. The contemporary artist must bring information that our restless eyes and memories have not already made stale.

Easy to say. So many brilliant people have worked so hard for so many centuries, deploying new techniques, new materials and new ideas, that it can seem hard to find something fresh to say. Jean-Michel Basquiat was an untrained Haitian-American artist from Brooklyn who died of a heroin overdose at the age of 27. But he had an eye and a sense of colour and line that meant that he could make explosive pictures which are brimming with life and like nothing else that had ever been made before.

All around the world every day, artists do exactly that. If you take the trouble to visit small galleries and hunt out the work, you will be thrilled and constantly surprised by what is being done near you, wherever you are, right now. But that art won't be all in one style, or mode, and it may differ shockingly. The question is – is it alive or is it dead? To begin to try to answer this, I want to turn in the next chapter to the very slippery, but inescapably

important, question of taste. Before we do that, however, we have to deal with an even more obvious question, the apparent division in modern painting between representational or "that's what it looks like" art and so-called abstract art.

PYRO, 1984 (ACRYLIC AND
MIXED MEDIA ON CANVAS)
Jean-Michel Basquiat

What are paintings of?

People who look at paintings properly would surely agree that the old firebreak between representational or "proper" paintings and "abstract" paintings is now completely useless. All paintings are representational – just of different things. What really matters is the quality of the representation, the thought that's gone into it. Because painting is a form of knowledge, it should not be cut off from other kinds of knowledge. Our understanding of the world around us is changing fast; and it is natural that painting should also be changing.

Take something simple – a picture of a field. Overleaf is a picture I made a few years ago in South Devon, and I think that in terms of composition – the way the curves meet, the role of the land, the use of curving dykes to tie the picture together, and so forth – it works OK. The soft reddish-browns and sharp greens fairly represent the mixed arable and grazing farming of the Otter Valley.

It isn't a great piece of painting – the brushstrokes are rather crude, it was done hurriedly and so on – but it's OK. Isn't it? No it isn't, not really. It's a sentimental, lazy, second-hand piece of work.

What is a field? It's a stretch of topsoil – seething,

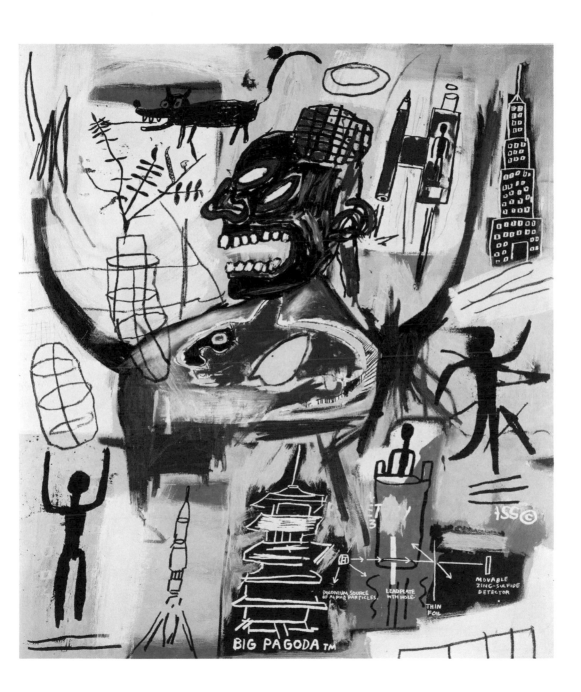

living, infinitely complex, a mulch of microorganisms, including many bacteria, fragments of shell and stone, decaying vegetable matter, water, feathers, bones – that allows the regular seeding and growth of plants, which in turn keep us alive. It changes colour and shape almost by the week. Anyone who drives past fields must see how quickly the farmer's work, as well as seasonal shifts of water and wind, alters them. So fields are moving.

For a painting of fields to be alive, the quality of looking must be much better than it is in this example. It's all about information. The Scottish poet Hugh MacDiarmid argued that to really see landscape, you need an understanding of its farming history, its economics and its biology – a knowing countryman's eye. In one of a series of poems with the Gaelic title *Direadh*, which means "act of surmounting" – quite close to transcendence, therefore – he describes the borderlands of Dunbar, whose soil and shape aren't so different from those in South Devon:

This is the cream of the country – probably
The cream of the earth, the famous Dunbar red lands.
These red loams combine a maximum of fertility
With friable easy-working qualities of unequalled perfection.
Potatoes, a level sea of lusty shaws and flowery tops
From a fence to fence in summer-time,
Then wheat, going to eight quarters an acre,
And then the swedes and turnips
Flickering strong and lusty...

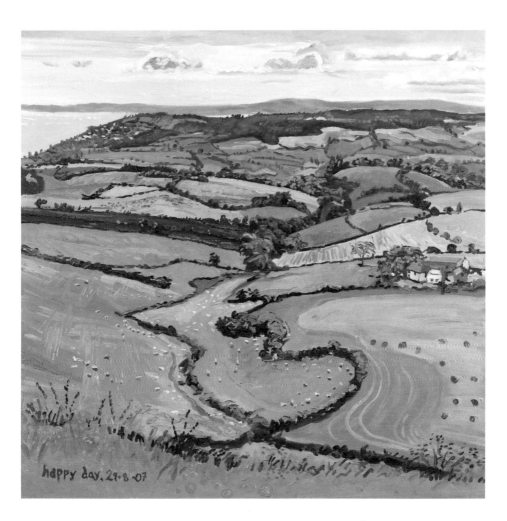

happy day. 29·8·07

This is as far away from traditional nature writing as modern painting should be from traditional landscape. Somehow, we need painting that's aware of the fast changes, the decay and rebirth – the hidden dramas – in the most humdrum field. But I think the best painters have always been aware

HAPPY DAY, 29.8.2007
Andrew Marr

of this. At the birth of modern painting, Claude
Monet was working more politically, and even
polemically, than perhaps many of his modern
admirers have noticed. In an important exhibition
in 1990 from the Museum of Fine Arts in Boston,
Monet in the 90s, Paul Hayes Tucker showed that
Monet's apparently innocuous subjects, from the
grain stacks behind his house to a stand of poplar
trees which he bought to prevent them being cut
down while he was working, had much to say about
the agricultural market, and indeed the state of rural
France, in his time. Monet talked with local
peasants and tradesmen: he knew exactly what
he was painting. It was very far from being a blur
of pretty colours.

A decent picture of something as simple as a field
can't be merely nostalgic, static, or made without
knowledge. While travelling with David Hockney as
he was drawing and painting in the East Yorkshire
landscape around Bridlington, I was struck by how
he felt he was relearning knowledge of the changing
shapes of leaves, plants and landscapes, and the
common sense of the farmers who have now
vanished from the scene; knowledge that needs
to be reabsorbed by a painter looking intently.

But as knowledge moves forward, the painter's
problems increase. The Russian Jewish sculptor
Naum Gabo, who influenced many modern British
artists, pointed out that a tree trunk is not what it
appears. It is "a mass of seething particles which do
not even keep within the bounds of its apparent skin,

POPLARS ON THE EPTE,
1891
Claude Monet

A SHORT BOOK ABOUT PAINTING

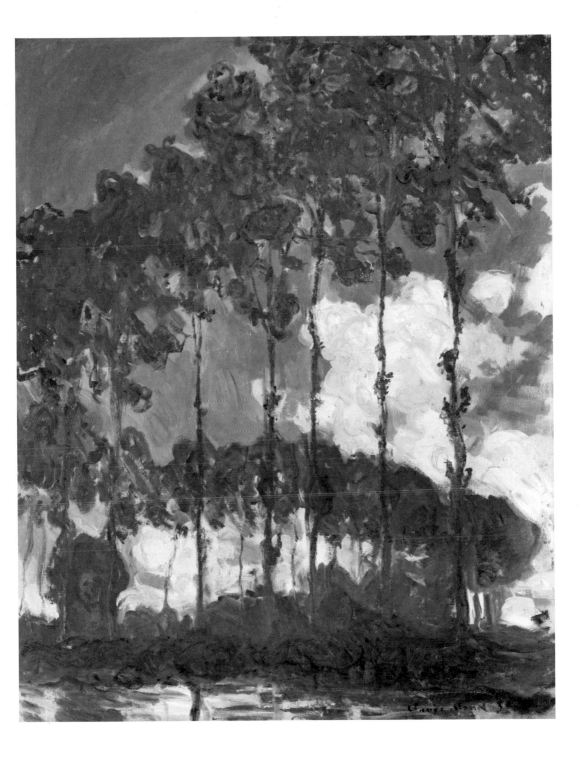

but fly out and mingle with adjacent matter."[1] That's modern physics talking. Under the most apparently static surfaces, matter is in constant, buzzing movement. How can painters begin to represent these things without falling back on the literalist numerical or symbolic scientific means? They can't. The job of the painter is to find other ways, not to mimic scientists. It isn't hard to see a version of the underlying instability of the world in the work of artists such as Paul Klee, Kandinsky, the Cubists or Jackson Pollock. But they have found other ways of describing truths, miles away from scientific diagrams. In the end, the painter produces a painting which must work in its own right. It must have its own bulk and identity, stand on its own feet and be the thing itself, not something "about" something else.

That isn't simply what I think. It's what the most eloquent and some of the best recent painters think as well. John Hoyland, a very successful non-representational painter throughout the second half of the 20th century and into this one said, "Painting is making form out of chaos. You can't end with chaos." Patrick Heron, another wonderful painter, said: "I hate all symbols in painting: I love, instead, all images."

One answer is what has been called abstract painting, which is merely image and colour working outside the obvious boundaries of mimesis. Bridget Riley, whose complex paintings of stripes have made her internationally famous, says that she tries to

1 Quoted by Patrick Heron in his catalogue for a Zurich exhibition, 1963

2 Bridget Riley, *The Eye's Mind*, Ridinghouse, 2010

realise "visual and emotional energies" at the same time... "Such things as fast and slow movements, warm and cold colour, vocal and open space, repetition opposed to 'event', increase and decrease, static and active, black opposed to white, greys as sequences harmonising those polarities..."[2] If Bridget Riley chose to paint a field in Devon, she would get much closer to the underlying realities than I did.

In the end, painters are not little gods but human beings, living inside nature. So we all return to the natural envelope in which we live for our art, whatever it looks like. John Hoyland, whose paintings can seem entirely "abstract" tells an interesting story about his own art, and that of the renowned Catalan painter Joan Miró.

At the time, Hoyland was friends with Robert Motherwell, the great American painter. Hoyland tells us: "I thought I could invent and invent and

invent. And Bob Motherwell gave me this book on Miró. I'd always thought that Miró had the greatest imagination of any artist in the 20th century, and then I found out that he went down to the beach every day and picked up bits and pieces, anything that he thought would give him a kick-start. And I realised that unless you're going to produce sterile geometric painting you have got to have some form of external inspiration. You can't live in a vacuum."[3]

So you go back to the world around you, whether or not you produce something that "looks like" that world. Clare Woods, a contemporary British painter, makes landscapes with poured and worked-over oil on aluminium, using masking tape and a cutter to give her hard black lines. She uses photographs, blown-up images, the sculpture of other artists; anything to – as Hoyland said of Miró – kick-start her pictures. Her landscapes are places of decay, darkness and menace – much closer to the reality of soil and nature than a sun-drenched "pretty" picture. To me they are modern, in the way that the poetry of Hugh MacDiarmid is modern.

Another way of dealing with fields, bringing new information and new looking to an old subject, came from the Cornish artist Peter Lanyon. After making dark, clotted, grimy pictures, which literally dug down below the surface of the Cornish landscape, Lanyon took up gliding. This didn't just let him see what had been familiar from many different perspectives, hanging from above, at the same time. It also allowed him to introduce the moving air that's

DEAD SPRING, 2011 (OIL ON ALUMINIUM)
Clare Woods

3 John Hoyland, *Unmistakable Identity*, Alan Wheatley Art, 2009. Quoted in the introductory essay by John McEwen

A SHORT BOOK ABOUT PAINTING

all around us and which we are so often unconscious of, into the body of his art. This introduced completely different perspectives – exuberant, perhaps "abstract" and yet entirely representational of Cornwall. Just as Monet made pictures which have changed forever the way the ordinary person sees French landscape, or the River Thames, so Peter Lanyon made pictures that have changed the way any thinking person sees Cornwall.

Now, of course, almost all judgements about art have a strong element of individual prejudice. I find the work of Woods, Hoyland, Lanyon and Riley speaks to me more about the experience of living in the world than does more conventional representational painting. But many people would disagree. Why, they would ask, should the insights into representation hard won by the Impressionists in the 19th century be cast aside?

Why can't they be used to describe the modern world as it is, just as Monet or Manet described the fast-moving Paris of their day? Well, there are painters doing exactly that and although they aren't entirely to my taste, these are formidable and honourable artists.

Two examples are Ken Howard and Pete Brown. Howard is hugely popular and many of his paintings are of completely predictable things – vases of flowers in a window, cornfields, Venice. But he also turns his skill to modern London street scenes, harbours filled with powerboats, or beaches covered in sun umbrellas and loungers. His composition and

his brushwork would have been wholly familiar to a painter starting out in 1910. His subjects, though, would be less so.

Similar points could be made about Pete Brown. His handling of paint is looser, perhaps more in the way of John Constable and the English tradition, but again he produces scenes which, in their colouring

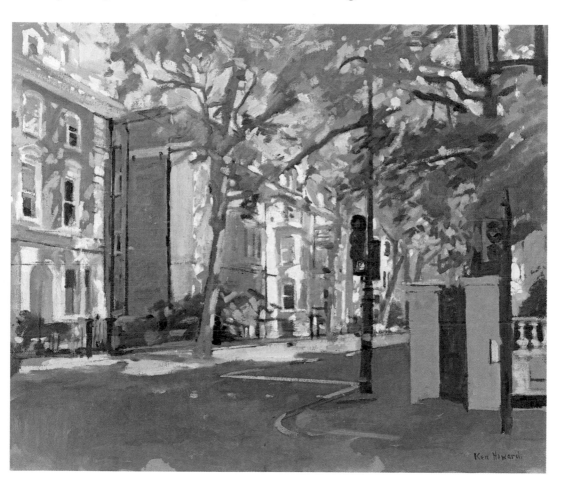

and composition, could have been made at almost any point in the past 200 years. But in other moods, Brown confronts the realities of modern urban life with great power. During the London riots of August 2011 he painted the aftermath and the burned-out shops, including Carpetright, in Tottenham High Road.

There is an old tradition of this as well, of course: Turner painted a vivid watercolour in 1792 of the old Pantheon Theatre just after it had been burned down. Still, if anyone in the future wants to know what London in 2011 could feel like, Brown's traditional representational painting is a good place to begin.

I don't want in any way to denigrate these two extremely fine and talented painters, but for me, the problem is that if you paint like Camille Pissarro or John Constable, even if your subject is defiantly and unmistakably contemporary, your picture will be like a Pissarro or a Constable several centuries after the event. You can't avoid that backward-looking, nostalgic atmosphere because it's deeply imprinted already on the minds of the viewer. You find yourself quoting – even if you are painting an ambulance or a set of traffic lights.

What's wrong with that? These are men making objects in the modern world which are a hundred times more worth having and enjoying than most of what is produced. But they don't – for me – lock into that sense of excitement and hard thinking, the feeling of being slightly off-balance and struggling

A SHORT BOOK ABOUT PAINTING

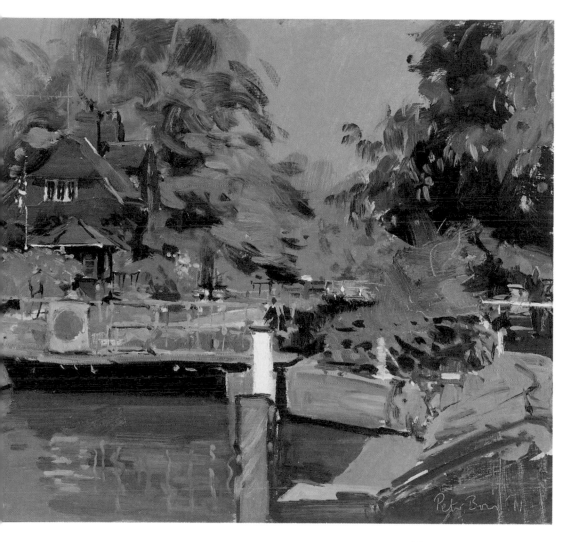

**SONNING LOCK,
LUNCHTIME, 2011**
Pete Brown

to understand things, that work by Bridget Riley
or Clare Woods gives me.

At this point it would be dishonest of me not
to mention that I have struggled with the same
problem of what to paint. One way of dealing
with change and decay in a landscape – movement,
different perspectives – is to layer the work, scraping
off and revealing different episodes in the same
painting. The painting overleaf is of wet and boggy
peat country in Wester Ross, Scotland, painted in
London. Very thin paint and very thick paint are
used to convey my memories of squelch and
aromatic instability. It's better than the careful
representational landscape on page 25.

There's not much more I want to say about it.
The ice-blues, the yellows, reds, oranges and sludge-
greens can be found in any patch of apparently dull
moorland; the black lines relate to the insecurity of
any path, track or direction. It's a simple picture,
but I can smell and hear the memories it evokes.
But if there's one thing evidently wrong with it, it's
that it quotes too obviously from the long tradition of
Scottish landscape painting. And that you could say,
in 2017, is bad taste.

Changing taste, and what is good taste and what
is bad taste, is such a knotty problem that it needs a
chapter of its own.

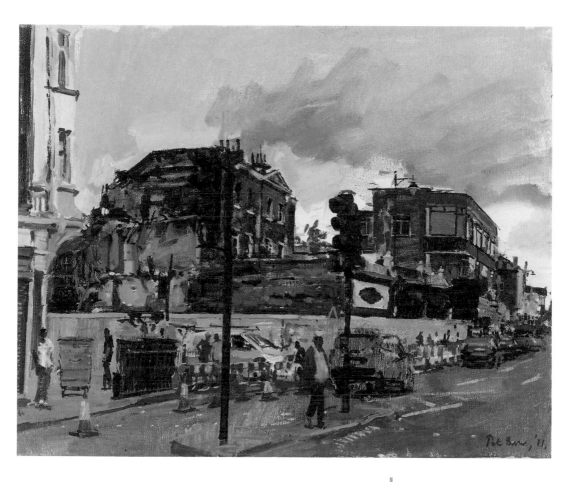

**TOTTENHAM HIGH ROAD:
THE JEWELLER, THE
HAIRDRESSER AND THE
POST OFFICE, 2011**
Pete Brown

A SHORT BOOK ABOUT PAINTING

**WALKING NEAR
GREENSTONE**
Andrew Marr

2 TASTE

On failure

Here is a picture I made which, while it has energy,
is in thoroughly bad taste. It's both a still life and a
celebration of summer – a kind of outdoorsy, picnic-
like explosion of exuberance. But it's also gauche –
look at the crudity, albeit deliberate, of the drawing.
And the nuzzling together of the jug and the semi-
abstract biomorphic shapes on either side of it breaks
a basic rule of painting, which is that there must be
coherence. You can't just stick a bit of one kind of
painting into another kind of painting, and hope the
whole thing coheres. When I first made this I was
cheerily pleased with it. Now I see it as a failure.

But what's wrong with failure? In the evergreen
words of Samuel Beckett: "Ever tried. Ever failed.

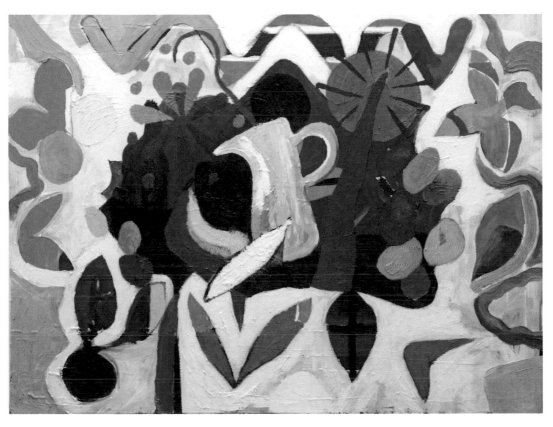

SUMMER PICNIC
Andrew Marr

No matter. Try again. Fail again. Fail better."
Several times a week, I struggle with very basic
problems of colour combination, balance, texture,
meaning and so forth. And fail again.

But what follows is not intended to be a
perverse celebration of failure, still less to praise
poor painting. This is a book about learning.
As we fail, we learn. Time and again, I find colour
combinations that don't work, basic structures that
fall apart, and imagery that is too obvious, banal or
second-hand. The centre of the picture starts, swiftly
and mysteriously, to collapse; or the edges press in
to devour it, or they themselves slide off into
oblivion. I can see the catastrophe taking place
under my fingers but, however much I sit and stare,
I am helpless to prevent it.

Kind people who say, "painting must be so
relaxing for you" don't understand what painting
is. As I swear and kick things and paint over the
latest failures I am conscious that all the time
I am learning.

By indirections, we seek directions out. And it
struck me that there isn't – at least so far as I can
discover – a book about failure in art, and how
we writhe and sweat and crawl our way towards
working a little more effectively. So, if you really
knew how to paint badly – if you had accumulated
in your head and hands experience of all the
possible mistakes – then, one way or another, you
would be well on your way to knowing how to paint
well, or at any rate to paint better.

"It was a kind of so-so love"
Marc Almond, Soft Cell

There is a vast trove of copycat, timid painting
clogging up many local art society exhibitions:
lovingly if stiffly rendered domestic animals; gory
sunsets over jagged coasts, and sub-Impressionist
renderings of back gardens, with too much blue in
the shadows. You see these, too, strung along the
railings of parks in central London, or exhibited on
easels in Montmartre and "artistic" small French
towns and they will not detain us here.

So-so art is inherently dull. You look at it. Your
attention flickers for a second: "Ah yes, I know that
sort of thing, I recognise what's going on." Then you
move on. That's why it is so-so.

Dedicated followers of fashion

As I mentioned in the previous chapter, this is also
about taste. The art world is various, jumbled and
fragmented. All around Britain there are art dealers
catering for people who want something nice and
cheerful to put on the wall. There are probably
hundreds of galleries – often in coastal towns, or
prettier county towns – selling perfectly well-made
and perfectly predictable pictures of flowers in vases,
sunlit high streets, or boats bobbing in the sea. Some
of them are entirely representational. Many others
are the kind of degraded offspring of modern art –
cutesily naive, splashy, and a very long way after Paul
Klee or Nicholson. There's a hierarchy of snobbery
involved. Aunt Louise is proud of a pastel of roses by

the retired lady next door in the local art class. But Cousin George is prouder because his flower painting is wilder, and done with a palette knife by a student. But I'm on the top of the tree: my painting of flowers was made by a member of the modern Edinburgh school, whose use of pinks and yellows has made her at least locally famous.

In other words, contemporary taste seems to require at least a nod to the mainstream of modern painting. Most people wouldn't want the full energy and extremity of a major modern painter inside their homes. They wouldn't want a Frank Auerbach of a claggy, filthy London excavation, the paint hanging off the wood, or a gigantic, bejewelled Chris Ofili of African faces and a rather obvious huge penis, complete with balls of elephant dung. Er, too much, chaps.

Yet it turns out that what very many people want is something by somebody who has learned from the way Auerbach puts paint on, and the way he has thought deeply about painting; or work by a younger artist, perhaps, who has learned from Ofili's subversive exuberance. Most people, candidly, prefer the gentler followers to the pioneers. Behind the pioneers, there always seems to be a second group who learned the lessons but then dilute, simplify and prettify. The history of Cubism shows precisely this. So does the history of the so-called Fauve painters of 1905–6.

A good parallel is fashion. The haute couture collections, eagerly followed by glossy magazines and

newspapers, are, to most people, largely ridiculous –
models used as coat hangers for the most extreme
fantasies of couturiers and hat designers. Few of
us are actually going to walk along the street in
shredded PVC, with pink knitted undergarments
and faces painted blue. Yet the great names of haute
couture are changing styles and expectations in ways
that will arrive on the high street very quickly – again,
the commercial rag trade dilutes, simplifies and

**BUILDING SITE,
EARL'S COURT ROAD,
WINTER 1953**
Frank Auerbach

prettifies the propositions the pioneers have made.

Perhaps there the parallel breaks down, because there are of course people who have paintings by Chris Ofili, or Peter Doig or Frank Auerbach in their houses. By doing so they are not only advertising their understanding and appreciation of contemporary painting – their grip on contemporary taste – but also nodding to their fabulous wealth.

Quentin Bell, that child of the Bloomsbury group who survived into our own times, wrote a useful book, which he bluntly called *Bad Art*, in 1989. One of the things Bell demonstrates is that because taste constantly changes, one generation's view of what is "bad" can be overturned by the next, which sees undiscovered virtues. Bell himself dislikes Pre-Raphaelite Victorian painting, which is now very much back in favour. The art of the curator is also a voyage of perpetual rediscovery, fine-tuning and reassessing old reputations.

If you go into the opening rooms of the Scottish National Gallery in Edinburgh, you will find huge pictures, which not that long ago might have risked being banished to some dusty basement. Two American examples tell us a lot about changing taste. Benjamin West's 1786 monster, *Alexander III of Scotland Rescued from the Fury of a Stag by the Intrepidity of Colin Fitzgerald*, is everything we recently thought we hated. The subject, for one thing: here is a noble wild beast being slaughtered by a gang of frenzied men with dogs, observed by four terrified horses. Then there's the treatment – the gestures not

A SHORT BOOK ABOUT PAINTING

just Mannerist but highly mannered and thoroughly implausible; stock, frozen faces, and too much muddy, brownish and slightly sloppy brushwork.

A second picture nearby by Frederic Edwin Church is about as big, but different in every other way. It's a huge painting of Niagara Falls, painted with an attention to detail – tiny brushstrokes over a vast canvas – that now seems borderline insane. But it reminds us that before the invention of photography, one of the crucial functions of painting was simply to show people what they otherwise

ALEXANDER III OF SCOTLAND RESCUED FROM THE FURY OF A STAG BY THE INTREPIDITY OF COLIN FITZGERALD, 1786 (OIL ON CANVAS)
Benjamin West

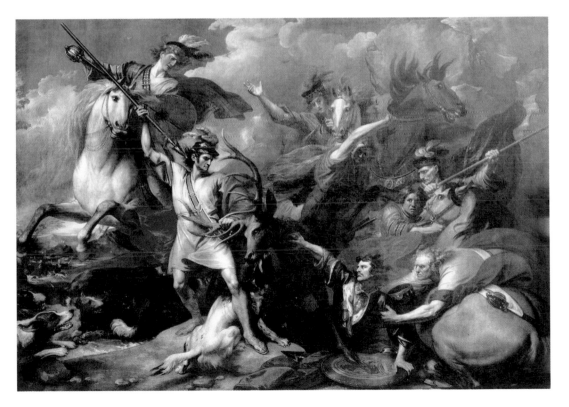

couldn't see themselves – landscapes from far parts of the world, portraits of great men and women, views of central Rome, Jerusalem or other iconic sites. Accuracy and scale were what the public wanted, and queued up to enjoy in huge numbers.

Both these paintings, which would not have been much admired at the height of modernism, take centre stage in the museum because we have learned to admire them once more, but in new ways. After some 60 years in which the traditional skills of realistic landscape painting have not been taught in art colleges, we can again gape at Church's sheer skill. And with the Benjamin West example, a renewed interest in Scottish history comes together with a greater admiration for the complex mathematics involved in creating work this big and this bonkers. There's nobody alive today who could do it.

So good taste, and bad taste, are slippery concepts. We can be reasonably sure that the values of today – our detestation of racism, for instance – affect the way we see art made under different ideologies. The sheer cruelty in many old paintings of fox-hunting or bear-baiting put them outside the circle of modern taste. But we can never be sure that any art is dead forever.

Quentin Bell's most useful distinction is sincerity. For him, the good artist describes the world full on, as he or she sees it directly, whereas the bad artist relies on what he calls "social beauty" or a second-hand common market of ideas. In every art movement of the past hundred years, he says,

NIAGARA FALLS, FROM THE AMERICAN SIDE, 1867 (OIL ON CANVAS)
Frederic Edwin Church

A SHORT BOOK ABOUT PAINTING

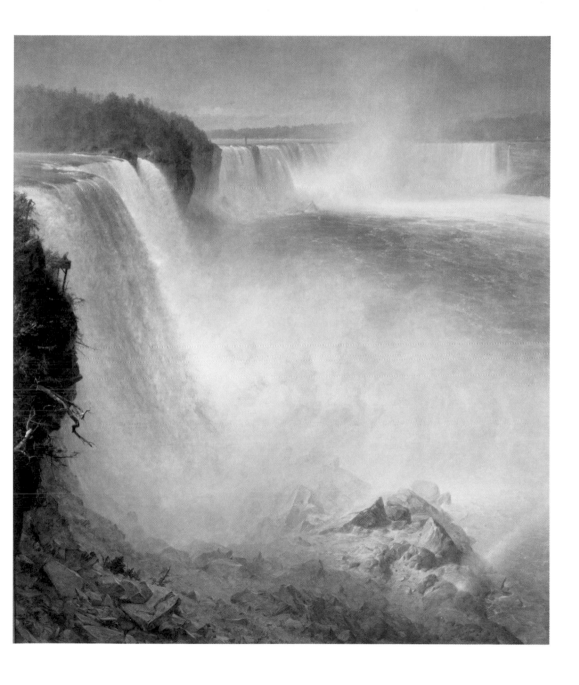

"the good artist has fought against the popular conception of beauty, the bad artist has accepted it at once or after a brief struggle." This, says Bell, explains why paintings by artists such as Landseer and Millais make him cringe. They "had completely accepted the opinion of their age as to what constituted a beautiful picture, and, having done so, addressed themselves to the beautiful with horrifying success." I would add Jeff Koons as an excellent contemporary example.

This understanding that versatility simply makes bad taste horrifying can be applied more widely today. Go online and look at the vast range of digitally drawn fantasy art easily available on the website Pinterest: imaginary space landscapes populated by pneumatic heroines; thick, ribbed woods with Gothic castles and muscle-bunny heroes; rusting space cruisers with cool punk chicks astride them... Here is an entire visual world of second-hand and half-digested images stolen from Hollywood films and pulp fiction, all the worse because so meticulously achieved. This has been done by artists who have completely accepted the opinion of their age... with horrifying success.

Bad taste comes from a lazy, slick readiness to slot into the expectations of the here and now. Thus, in our time, bad taste must be intimately linked to the digital revolution. We live surrounded by a multicoloured, vivid, sexualised and glassy hyper-reality. It's easy for technically competent artists to use digital drawing tools, or even simply acrylic

**TRIAL BY JURY, OR
LAYING DOWN THE LAW,
c.1840 (OIL ON CANVAS)**
Edwin Landseer

paint, to produce glossy, smooth and apparently provocative art which has made its diabolical pact with the modern world.

Again, Quentin Bell, here describing Victorian taste, offers a sidelight on the 21st century. Our stuff is different, of course – digital rather than material – but doesn't the following ring a bell or two? "No other age... clamoured for beauty as a child clamours for sweets; it produced beauty by the ton and by the square mile, it applied beauty with reckless profusion

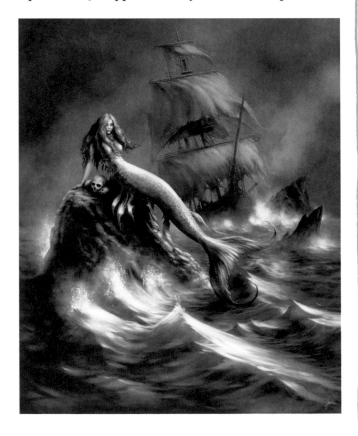

MERMAID
Jason Heeley

A SHORT BOOK ABOUT PAINTING

to every available space in the form of frills and flounces, stucco and gutta-percha mouldings, buttons, beading and Berlin wool, Lincrusta, papier mâché and Britannia metal, crockets, buttresses, cherubs, scroll work, arabesques and foliage…"[1] Think of our buildings, clothing, malls and screens too. Trump art.

So here, at last, is the case for good painting. Modern digital culture is changing much of what we have been living with for thousands of years – birdsong, the smell of rotting foliage, a world of torn clouds and watery paths, the erotic and the tragic, the cold and brightness and the deep, deep dark. Living through screens drives away the reality of what it has been like to be alive on this planet.

Reality, by contrast, resists us. It is cussed and surprising, with sharp edges and inexplicable patches, so it must be pursued with visual curiosity and exactness. The talented artist with the pleasing manner – the bad artist – is the artist pretending that reality easily conforms, and moulds itself, to pre-loaded human expectations. But if we "already know "what a beautiful human face looks like, or a "satisfying" landscape, why bang on? Why copy out yet another example?

Good painting is surprising because it returns us, with a jolt, to realities we too often evade. The eye can't slide across it and move easily on. And that's about hard-won technique and skill. The painter Patrick Heron once said that Rembrandt's beauty "was not in the old man's face (which is like many faces you may see anywhere) but in the abstract

1 Quentin Bell *Bad Art*, Chatto & Windus, 1989

crystals of Rembrandt's paint surface (which is only found in a Rembrandt)…"

Compared to slick art, I am more interested in heroic failures – art which was done by someone at full stretch, with sincerity and seriousness, some degree of skill, and yet which falls flat on its nose. There is a gallery in Venice, the Ca' Rezzonico on the Grand Canal – a lovely, cool, welcoming place, which specialises in the art and furniture of the Venetian 18th century. So it tells us what happened to Venetian painting after all the greats – and their immediate successors who had learned from them – had died. We know of Titian, Veronese, Tintoretto

JUDITH
Giulia Lama

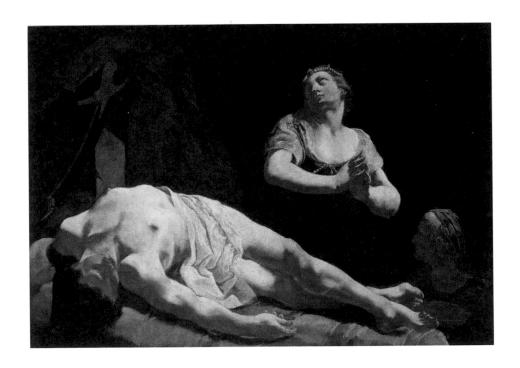

A SHORT BOOK ABOUT PAINTING

and Giorgione; and art scholars know quite a lot about their pupils and those who copied from them across Europe. But what happened next? After the golden age of Venetian art, and then the silver age, what follows? Giulia Lama, that's what.

Art history is obsessively eloquent about the growth and development of schools and styles, but largely silent when it comes to declines and falls. The Ca' Rezzonico is full of competently brushed, carefully drawn and achingly sincere monstrosities – fat, ugly angels doing nothing in particular, constipated monks, unpleasing random butchery and so forth. It's absolutely fascinating.

Then, to jump forward in time, it's not the case that every great artist carries on developing and getting better. To take one example, the French Fauve painter André Derain was at first an absolute hero, breaking barriers and boundaries, shoulder to shoulder with Matisse, Dufy, Braque and Vlaminck. Then he somehow, mysteriously, "lost it" and produced dun-coloured faux-classical pictures for the rest of his life. You can see them in some French collections and you always think, "Gosh. That's rather dull. Wonder why they've hung it? Oh! It's by Derain…"

Taste is complex when it comes to modern art. But that doesn't mean it doesn't exist – or that there aren't any objective hierarchies. Shows by the greatest modern painters may be easy or difficult but they attract vast crowds who carry on paying the entrance fee and coming back, day after day.

The David Hockney retrospective at Tate Britain in early 2017 broke all records for pre-ordered tickets. Rooms of video art, charcoal drawings and what the artist himself described as gay propaganda, were choked with people who had travelled from all over the UK and beyond. At the same time, an exhibition of portraits, mostly highly non-representative, by the late Howard Hodgkin, was buzzing – people were laughing and talking loudly about almost every picture.

There was something in those rooms that many thousands of people felt they needed and wanted and would make a great effort to see. The brutal competitive questions of what people revere and what they don't challenge all contemporary art curators, and they are real ones. Stepping into a minefield, I would propose the following few simple thoughts.

First, people are attracted still to very strong colour combinations and to coherent composition – as Hoyland said, you can't end up with chaos. Second, the subject of art remains important. The subject doesn't have to be literally present – Clare Woods paints about decay and fear, Gillian Ayres about the exhilaration of being alive. But it may be literal: Kiefer's art deals directly with Germany's modern history and the possibility of imminent environmental collapse; Auerbach describes modern urban living, with its confusions and collisions. If there isn't something in the subject to get your teeth into – if it's all floral arrangements

or beach scenes – the public reaction will be tepid.

Third, and perhaps most important, art must look somehow fresh, novel, of the now and not of the then. If it does, the "now" can last, however. Go to see an exhibition of Rauschenberg or Jackson Pollock paintings from the 1950s and their freshness bursts from the walls. People don't want imitations of the past, certainly if they're spending good money on going to an exhibition.

Finally, modern taste seems to prefer paintings that look like paintings. Surrounded by a glossy sheen of digital imagery – on your tablet, your computer, iPhone or television screen – you don't want cold, glassy, smooth surfaces from living paintings. You want the marks to be visible, the hand and the eye to be still somehow present. You want to live in the here and the now.

You may think that these principles are so obvious as to be banal and useless. But I need to start somewhere. So let's try at least to remember them as we dig a little deeper, heading on next to the problem (if it is a problem) of colour.

3 COLOUR

What is colour?

The modern, scientific answer could be summarised thus: it is the brain's apprehension of the energy of the cosmos.

The colours of the spectrum are different wavelengths of light energy, electromagnetic radiation, ranging from red in the least frequent waves, to purple in the most frequent. The wavelengths enter the human eye and are noted by the six million receptor cells on the retina, organised in three kinds of rod and cone cell. Different cells are more or less receptive to different wavelengths – that is, different colours. Rod cells in particular are incredibly sensitive, tracking differences in frequency of as little as one nanometre, that is

one billionth of a metre. These cones contain opsins, or photo pigments.

The information then passes from the retinal ganglion cells along the optic nerve from each eye. They cross over, and then the optic tracts continue the journey to the thalamus, deep in the centre of the brain, and thus to the visual cortex, the main processing area at the back of the brain. (The common phrase "eyes in the back of your head" is rooted in neuroscience.)

There, colour-processing cells are arranged in blobs concentrating on red-green and blue-yellow "flavours". The rods and cones in the eye only pick up certain wavelengths – in a sense the information they are sending back is pretty crude – and it is here, in the visual cortex, that the brain finally makes "sense" of our complex multicoloured world.

I am brutally summarising a much more complicated picture and I'm sure neurologists would suck their teeth. But in a book on painting, we don't need much more information than that. The important thing to remember is that "colour" is wavelength, part of the electromagnetic energy of the world we live in. More specifically, colour is how the brain processes the wavelength information. With our vision, we suck in the energy of the cosmos and break it down to understand what's around us.

This at once raises fascinating questions. Since every human is different, it's perfectly possible that our visual cortexes are not quite the same, and that

therefore every one of us apprehends, say, dark red slightly differently. Ethnologists tell us that different human groups have evolved more or less sophisticated colour awareness depending on their environment – for instance, the Inuit apprehend snow with special subtlety, and Amazon tribes similarly have a special sensitivity to different greens.

Since the artist is trying to communicate with as wide an audience as possible, this information isn't particularly useful and is slightly unsettling. If my bright yellow is different from your bright yellow, there is damn all I can do about it. The condition of synaesthesia, in which perceptions are mixed up, so that some people can hear the sounds of colour, or taste sound, reminds us that this is a fluidly subjective matter.

Science certainly shows that different species have different quantities of cone and rod receptors, so see colour differently. It would be bad news for a painter to be reincarnated as a cat or a dog since, like many other mammals, they have two, not three kinds of receptor and therefore presumably apprehend less colour than we do. Worse would be to come back as a seal or a whale, since they have only one kind. On the other hand, since many birds and fish have more than three kinds of cone cell their world is probably more coloured than ours. It has been suggested that pigeons and butterflies have five. I hope that if Titian was reincarnated, he returned as a turtledove or a red admiral. It would have been a short second life, but a merry one.

More seriously, what I take away from this is that colour is a profound register of reality, of the constantly moving and dynamic world around us; it is also, literally, deeply rooted in our brains, and therefore our imaginations and emotions. To talk about the power of colour is anything but arty-farty.

Pigmentation

For a painter, however, this is just the very start. The colour we use, whether it comes in a metal tube, a bucket or a spray can, has been plundered from nature to give us more intensity. Pigment is the visual sibling of spice; and it's interesting that the most expensive pigments, such as ultramarine, traditionally had a price that was only rivalled by the cost of the most expensive tastes and smells, such as nutmeg or frankincense. The lusts of the brain accept no parsimony.

Pigments are the finely ground substances which, mixed with liquid – oils, water or synthetic media – pass on their colour without fading or decaying. The search for and use of these pigments is almost as old as the human story itself and they can come from minerals, plants and animals. Lapis lazuli, for instance, is a semi-precious stone found in Iran and Afghanistan, and also in China. When separated from the surrounding greyish rock, it produces an intense and long-lasting blue which has been valued for centuries. The Babylonians used it for decoration and European painters were shelling out vast amounts of money for it throughout the Middle Ages and into

the Renaissance. These days, it has mostly been replaced by artificial ultramarine pigments.

Cinnabar, a bright vermilion red, came from Spanish mines. Ralph Mayer's *The Artist's Handbook of Materials and Techniques* contains some wonderfully laconic descriptions of other pigments. Indian yellow, for instance, is "an obsolete lake of euxanthic acid made in India by heating the urine of cows fed on mango leaves." Tyrian purple was "prepared from the shellfish *Murex trunculus* and *Murex brandaris.*" Of Vandyke brown he says, "Native earth, composed of clay, iron oxide, decomposed vegetation (humus), and bitumen. Fairly transparent. Deep-toned and less chalky than umbers in mixtures. One of the worst dryers in oil…"

These days almost all artists obtain their colours from commercial suppliers who produce them synthetically, allowing for reliable results. We don't have to grind up bugs, steep vegetation in urine or clamber up mountains with pickaxes. But the origins of pigment really matter. Painting was from the first a physical activity rooted in the world of nature around painters – the insects, the barks, the herbs. A painting was a material object composed (for instance) of oils from seeds and ground-up soil and rock. It might look like a madonna or a dragon, but what it was, was dust and pith and juice on wood or vegetable fibres.

This materiality is worth recalling and valuing in a world becoming ever-faster a virtual one. It is, I suggest, a virtue: if colour is electromagnetic energy, sorted inside the wet organic electrics

of the brain, the stuff of painting also roots us in nature. The best painters know this. I have a friend called Adrian Hemming, whose landscapes require a special blue he has made up for him, and grinds meticulously with a knife. For watercolours of nature, the very fine painter William Tillyer uses pigments created from the same North Yorkshire soils and plants he is describing.

This is not, in any sense, to advocate some kind of ruralist reaction, a literal back-to-the-soil movement away from the modern world; Tillyer famously uses industrial materials, handles, plastics and the latest acrylics as well. But it is to say that colour is both constant movement, and entirely material; which is, in short, why painting, far from being a dead or dying tradition, is still exciting and thoroughly part of contemporary life.

Colour language

Writing in 1962, the painter and critic Patrick Heron declared that colour was the only way forward for modern artists: "Colour is both the subject and the means; the form and the content; the image and the meaning, in my painting today. It is obvious that colour is now the only direction in which painting can travel today."[1]

This caused some offence at the time but Heron, whose paintings had indeed banished any forms more complicated than a rough circle or a rough line between colours, wasn't so much attacking all representation as archaic, but making a case for the emotional impact of pure colour in a dissatisfying world. "One reels at the colour possibilities now: the varied and contrasting intensities, opacities, transparencies; the seeming intensity and weight, warmth, coolness, vibrancy; all this superbly inert 'dull' colour – such as the marvellously uneventful expanses of the surface of an old green door in the sunlight. Or the terrific zing of a violet vibration... I can get a tremendous thrill from suddenly seeing two colours juxtaposed."

Here, I think we are coming close to the heart of the matter. We all absorb our colour palette from the world around us. This gives colour fundamental meanings that artists can't really escape. Green is chlorophyll, grass, growth, fecundity – but dark green evokes shadows, dank and dismal places, even poison. Red is the colour of blood, fire, sunset and heat. Yellow is the sun's colour, but also the colour

1 Zurich catalogue, quoted in Heron, op cit

A SHORT BOOK ABOUT PAINTING

JANUARY 1973: 13
1973
Patrick Heron

of sickly skin, of disease. White is cold, frost, snow, ice, the north, logic, intellect. Blues, which are always cold, are the colours of the skies and seas.

We can't get away from these thoughts, any more than a poet who is interested in the sound of language can get away from the literal meanings of the words he deploys – although some, like Swinburne, tried very hard. These correspondences slide and jar; we can subvert and reject them, but they burrow back and snap at our fingers. In a series of *White Stones* pictures (see page 67) I've been making of underwater themes, where the colours are heightened but also blurred, there is a whole family of blues, ranging from threatening indigos to softly benign light purples and turquoises, closer to the sun. The yellows, greens and reds towards the bottom third seem to me to represent organic life and danger.

There is a long and interesting tradition of writing about colour combinations and contrasts. Why do some colours simply seem to go well together – blue and yellow, red and green? These harmonies seem to belong more to music than to vision and yet they are very powerful. Partly it's about what sits where on the spectrum, and which primaries combine to make secondary colours. But I also think there is a simple, primal sense in which the yellow of the sun and the blue of the sky have sat alongside one another forever until they are deep inside our understanding; and red earth and green growth likewise. One aspect of the job of a painter, as above, is to take and reshape these expectations.

Cleaning Windows – the title comes from the Van Morrison song I was listening to as I finished it – is "about" a windy, hot, summer afternoon, and the colours refer to bright clashes and unexpected juxtapositions as the glass swings, and indoor becomes outdoor, and vice versa.

Just as composers can hear and emotionally respond to chords of greater complexity than most of us are able to apprehend, so painters have the same emotional responses to colour combinations as the rest of us – but more so. Ever since I was a small boy I have had very strong responses to colours. The golden-yellows and red-browns of a Perthshire autumn, streaked with violet undershadows; and the throbbing turquoise, green and dark blue combinations of the Atlantic seen from the Scottish Highlands run through me still, in my dreams and

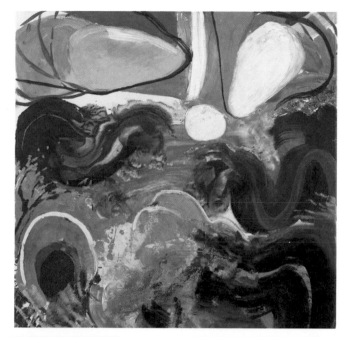

right
**THE WHITE STONE AND
THE BATTLE AT SEA
MARCH**
Andrew Marr

below
CLEANING WINDOWS
Andrew Marr

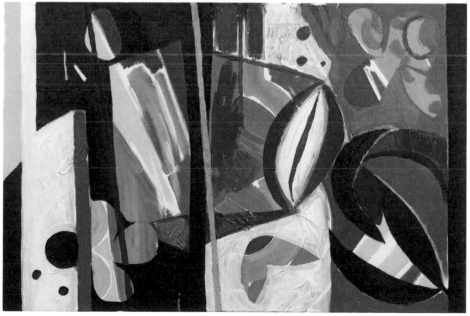

daydreams. Colours, even divorced from discernible shapes, make me happy and sad, energetic and depressed and this seems to be common to painters.

In a beautiful essay Bridget Riley argued, "I don't paint light. I present a colour situation which releases light as you look at it." She goes on to ask where this comes from: "Long before I ever saw a major painting... I had been fortunate enough to discover what 'looking' can be... I spent my childhood in Cornwall, which of course was an ideal place to make such discoveries... Swimming through the oval, saucer-like reflections, dipping and flashing on the sea surface, one traced the colours back to the origins of those reflections. Some came directly from the sky and differently coloured clouds, some from the golden greens of the vegetation growing on the cliffs, some from the red-orange of the seaweed on the blues and violets of adjacent rocks, and, all between, the actual use of the water, according to its various depths and over what it was passing. The entire, elusive, unstable, flicking complex subject to the changing qualities of the light itself..."[2]

This returns us to colour theory, the attempt to explain or codify the emotional impact of different colours, and different colours in combinations. I mentioned this in the previous chapter briefly, in regard to Kandinsky and it's something painters tend to think about quite a lot.

Patrick Heron wisely suggested that there is a limit to how much we can understand about this verbally. Words, he pointed out, are not paint:

2 Bridget Riley, *The Eye's Mind*, *Collected Writings 1965-2009*, Ridinghouse, 2010

A SHORT BOOK ABOUT PAINTING

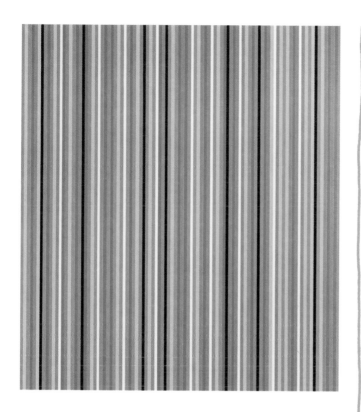

**WINTER PALACE, 1981
(OIL ON LINEN)**
Bridget Riley

"I have always found that it takes at least twenty
times as long to describe in words any specific
feature of a painting of mine – a colour-area of
cadmium scarlet scribbled, delineated, filled out
by brush-marks or brush-weavings of this nature
or that."[3] But some basic points can be made.

We start with the hierarchy of primary colours –
red, blue and yellow – from which other colours can
be mixed, but which cannot be produced themselves
by other colours. This does seem to relate directly
to the three different receptor cells on the retina.

3 1978 E. William Doty
Lecture, *The Colour of Colour,*
op cit

Further, as I mentioned earlier, the human brain does appear to find that some colours go well together or complement one another – blue and yellow, red and green. I have not yet read a compelling account of why this should be so, though I've already made my amateurish stab at it earlier in the chapter. As we've seen other colours can clash almost painfully – an acid green against a bright pink.

But what, finally, of the emotional effect of colour? Is there anything secure we can say? With due caution about the individual perception problem, most people recognise a contrast between hot or warm colours, the reds, oranges and yellows; and the cooler blues, greens and whites. If you doubt this, consider why "cold orange" or "hot green" don't, to most of us, make much sense. We feel it on the body. I'm surer than ever that these distinctions emerged early from our perceptions of the world around us – the warmth of the rising sun, the glow of burning wood, or cold, misty blue winter days – and that they have become somehow rooted or innate.

A final example here is a picture referring to a card or board game, in which several overexcited players jealously compete. The colours are – almost – all. Oddly, if the motifs were less crudely painted, this picture wouldn't work.

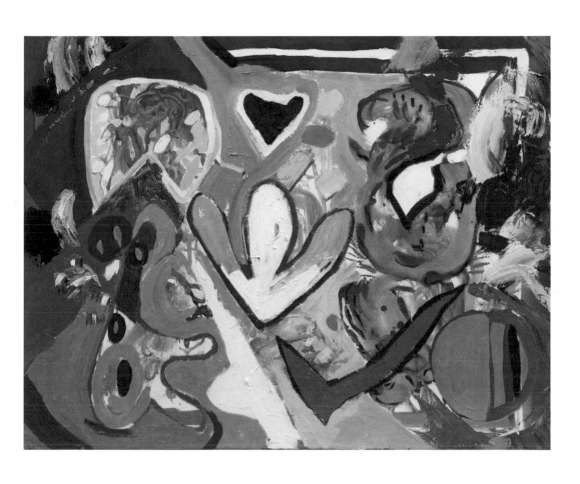

4 MOTIF

I have argued that powerful contemporary painting must have a subject. By that I don't mean that it must look like something directly, but more that it must have a point, a meaning. That can be, by and of itself, colour – and the emotions summoned by colour – or the texture and the doing of the artwork itself. Or the simplest compositions can summon existential thoughts. It isn't "pseudy" or unusual for people standing in front of paintings by Rothko to feel that they confront death and obliteration, and even to be made dizzy by them. Kazimir Malevich's famous black square – it is what it says it is – summons up a different kind of confrontation, the world-ending despair of global war and revolution. Barnett Newman's so-called "zip" paintings –

ADAM, 1951–2
Barnett Newman

thin vertical lines of colour against a different coloured backdrop – nevertheless managed to summon up heroic Jewish mythologies.

Malevich was painting both within and against the tradition of Russian icon painting, which can be notably stark, while Newman was responding to the almost inhumanly large figures of the age of prophets. Both found that almost entirely motifless canvases could bear the weight of substantial meaning. For other artists, intense colour can replace the need for complex imagery. Robert Motherwell's famous series of elegies for the Spanish Republic, with their boulder-like black ovals and blocks, depend upon the harsh yellows and occasional bright gleams of red, alongside the ominous black shadows, to make the viewer think about the bloodthirsty political tragedy that preceded the second global war. So "must have a subject" doesn't mean "must have a human figure in it" or "must show a tree".

Circles and wiggles

So far, so comparatively easy. But anything more complex than a square or a straight line is likely to summon up some representational response in the viewer. If we see a wobbling horizontal line a third or two-thirds up a canvas then we will think, "horizon". We can't help it. The painter can't help it. If we see a circle, we think sun or moon. The most vestigial scrawl can automatically find itself translated into something such as a tree, running figure or rabbit. That's simply how our minds, tuned to make sense

of the world at huge speed, work. So a painter who doesn't want to represent, primarily, a line of hills in the distance or a rabbit or a church, but is trying to show something else, something more complex, has to work pretty hard at the problem of the motif. There will be something – there must be something – of shapes in the paint. Where will these shapes come from? From the world around the painter. The contemporary painter – remember Joan Miró scouring around on the beach – is likely to be forced back into nature to be kick-started. And yet, when the painter comes back to the studio, he or she doesn't want motifs that can be misunderstood as traditional representation. It's a hard problem.

Yet, like so many hard problems, clever people have found ways to deal with it. Bridget Riley, by slashing the world into thin ribbons which may intersect and dance with one another, created a whole way of representing things which is complicated, subtle and yet avoids the problem of motif.

Gillian Ayres, another hugely important painter of the same generation, made her earlier works using very rough circles and oblongs of thick, smeared paint, so much so that visible shapes virtually obliterated one another and the viewer was forced to think differently. There were motifs there; but there weren't. In her later paintings, she devised simple motifs – triangles encasing squares, long patterned tendrils, diamonds and Matisse-like leaf formations – which could be read as organic shapes, stars or whatever. And yet she kept them so simple in outline

and so blazingly powerful in colour that the shapes ceased to be terribly important. They were the hooks on which she hung meditations about being alive, about energy and light, rather than visualised objects in their own right.

Another approach to the same problem has evolved in the art of Fiona Rae, now one of the most popular members of the Royal Academy in London. She crashes different kinds of motif or image into one another on the same picture surface. You might

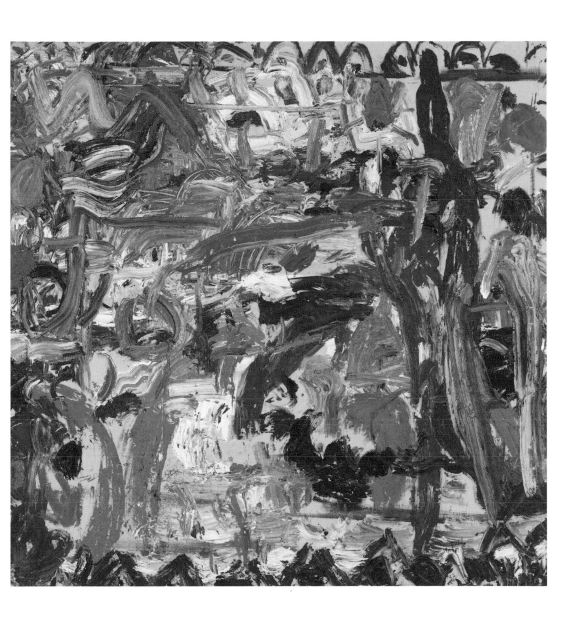

find little Japanese figures, of the kind that populate computer games, cohabiting with thickly worked or smeared gobbets of paint; neatly stencilled circles which might have emerged from a book on mathematics; butterfly shapes and Day-Glo explosions. Fiona Rae gives us so many kinds of motifs, so many layers of meaning, that we are almost forced to shrug them aside and to think about the painting as a painting – about its complexity and its energy.

All these artists are dealing with the same conundrum – that we want something for the eye to hang on to without trying to fool the viewer that they are seeing a copied representation of real objects. Painters as various as Jackson Pollock and Mondrian ended up with motifs that, whether they wished them to be or not, could be "read" as references to the real world. The wiry arterial dances of Pollock's paint refer to the movement of his own body and the energies inside it; the grid of a Mondrian abstract appears to be a map of urban traffic. The problem simply won't go away. Many 20th-century painters shrugged and accepted that there will be motifs. Paul Klee played with them – sea monsters and birds, traffic-directing arrows and the cupolas of Mediterranean cities dance through his essentially non-representational art. The great Kandinsky refers to riders, horses, angels and alpine landscapes in his networks of coloured lines.

Quite quickly, we realise that there is no such thing as abstract art, assuming that abstract means divorced

from the world of signs and things. A painting by Ad Reinhardt – flat, barely inflected pigment on canvas – is nevertheless an Ad Reinhardt, a thing, a sign, which means "a lot of money", or "part of the history of New York abstract painting". These are just as much signs as a ruff painted by Nicholas Hilliard, or Carel Fabritius's *The Goldfinch*.

Vision evolved not to give us artistic pleasure but to keep us alive – to enable us to hunt food, avoid danger and so forth. We are unable to see without reading messages and decoding them, without using signs all the time. Artists who attempt to keep us focused on, for instance, the material surface of the picture plane, or thinking about the act of painting, or the simple effects of different colour combinations, will all end up having to accept that image decoding cannot be divorced from the present business of looking. Perhaps the best thing is to accept this, and to use motifs deliberately but as simply as possible.

This is difficult, however, and to show why, here is a series of pictures I made when I had decided that *the studio* itself would be as plain a motif as I could use. These would be pictures about starting to make pictures again. I wanted a light source coming from the top or back of the room; a very plain rectangle represents the easel and canvas; and around that basic blocks of colour represent walls, outdoors and so forth (a, overleaf). I wanted to keep the thing as scumbled and loosely painted as I could in order to emphasise the lack of a "real" studio. And, because I was interested in overpainting older work, I wanted a

target image from an earlier picture to be still dimly present in this one.

So far, so good. I went on – further adventures in the studio – to heighten some of the colours, emphasising the shadows more strongly and playing with the idea of being inside and outside at the same time (b) – for the studio is both a lightbox and a window. Again, these are very traditional thoughts and I continued keeping the paintwork deliberately loose and obvious. But already I am in trouble. Forget, for a second, that the yellow and the cheesy red in the background go unpleasantly together. It's a different time of year and the light is artificial. The problem is that the "motif" is now a little too strong to be a motif. It has become an upended object with a shadow uneasily placed between a landscape and a room. In short, it is neither one thing nor the other – it is not a representation nor a well thought-through dance of attractive colours. In pushing forward, I am falling back.

The motif, then, has a life of its own. A studio contains an artist (otherwise it wouldn't be a studio) and a model or at least a subject. And so I moved innocently ahead, representing the artist in various guises as, for instance, an open eye and a palette; while a model to the right of the picture appeared variously as a buffoonish Gauguin caryatid or a series of stripped-down geometric colours (c).

By now, as you can see, I am making a right mess. The great golden swathe of light falling diagonally across the picture plane is pleasing enough, or at

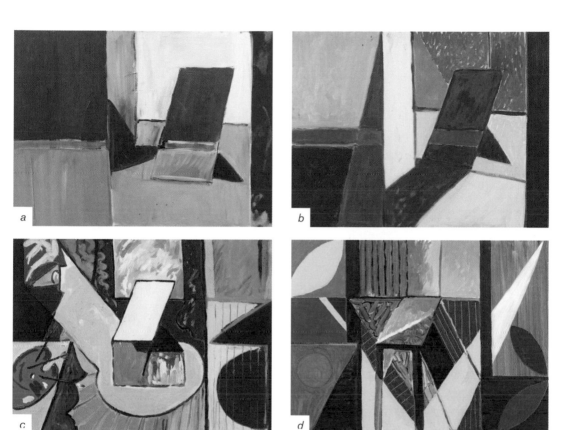

a

b

c

d

least it is to my eye, but the caryatid on the right
has vanished into a semicircle and triangle; and
representing the artist by an eye is something
Picasso might have got away with, but I haven't.
By including some painting materials on a table,
I have slipped in the direction of representation.
If I'm trying to represent a real studio, why not
paint it properly? The motifs have taken over and
made a fool of me. One answer to this is to return

to simplifying everything and knocking back representation (d, page 81). I wanted to keep the sense of light, of inside and outside jousting against each other; and also of the materiality of the room, which included floorboards. The artist and his model have now completely retreated to triangles, circles and leaf shapes.

This works better; at least there is a satisfying sense of balance and harmony, alongside the energy of the light. But it's all a little too balanced and calm, and by now quite a long way away from the original studio idea.

So I changed direction again and this time, after all those failures, I began to paint a little better. The energy of the light, I realised, comes from strong colour contrasts, not from diagonals or cones. I could keep both the artist and model, radically simplified, and use the floorboards to give a sense of the outside world pushing in. I emphasised the central canvas, which had rather vanished, and brought in a sun from outside, to flame away and keep me warm – all this was painted during the winter.

You may well disagree but *Winter in the Studio III* seems to me a better picture than any of the previous ones, and one that could only be arrived at by struggling with the problem of the motif. It's rough and it's crude but it has movement, energy, and it does reflect for me the experience of working and painting in a particular room at a particular time of year.

A SHORT BOOK ABOUT PAINTING

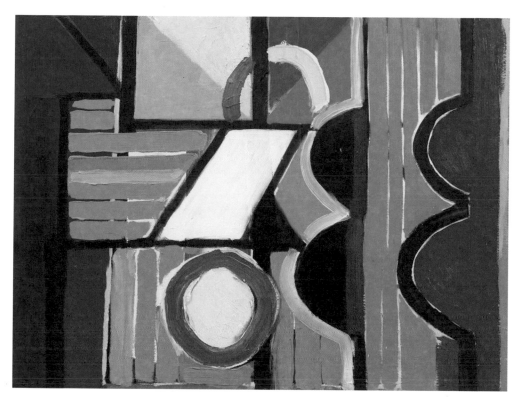

In more detail: a study of failure

Some time after I had finished the "studio" pictures,
I began to make a series of pictures with a different
theme – going for a walk. I used semicircles moving
from the right towards the left to give me a basic
structure, with dark triangles for their shadows, and
diagonal black lines, sometimes with circles, to mark
out the rest of the picture plane. They had to be the
size of a single rotation of the wrist. What I was
trying to do was to give a visual shorthand for
movement through different landscapes, using

**WINTER IN THE STUDIO
III**
Andrew Marr

varied thicknesses of paint for air quality and energy. So these were not, properly speaking, abstract pictures and indeed each one, as it developed, represented the memory of a particular place and walk for me. I didn't set out with this in mind, but as the pictures formed that's what happened. Here is the first of them (a). As you can see, I was interested particularly in texture, and in this case the effect of dropping raw pigment on to wet paint as part of the process.

That first picture was about a walk in Cambridgeshire in the late autumn, with a lot of cold light, and yet the warm crackling colours of decaying farm foliage. The next picture, again with a firm stride from right to left, was about walking just outside Dundee, where I was born (b and detail). Although in many ways the pictures are similar, I hope you can see that the added cold blue and white produce something very different.

At this point I felt I was on to something – pictures whose motifs represented something real and felt, with the structure that was my own, not borrowed from anyone else. In the first sketches, such as (c, overleaf), there are vague memories of Russian constructivist painting but they aren't so obvious as to get in the way. What makes these pictures a bit more interesting in the flesh than they are on the page is that there is a deliberate dance or conversation between thick, impasto paint, sometimes scattered with pigment, and much more loosely painted areas. For me this is a way

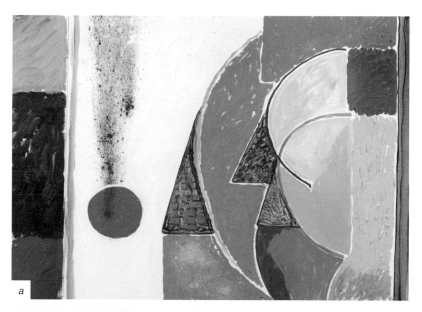

a

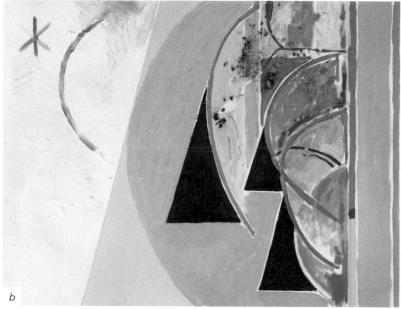

b

of portraying physical experience and breathing, though I can't quite explain why.

At any rate, things were chugging along nicely and I had that dangerous sense of overconfidence that comes when you are on a roll. Each picture started with a very simple piece of drawing – about as simple as one can imagine.

And on that structure I could hang an ever-greater variety of colours and shapes and textures, always referring to a specific event.

c

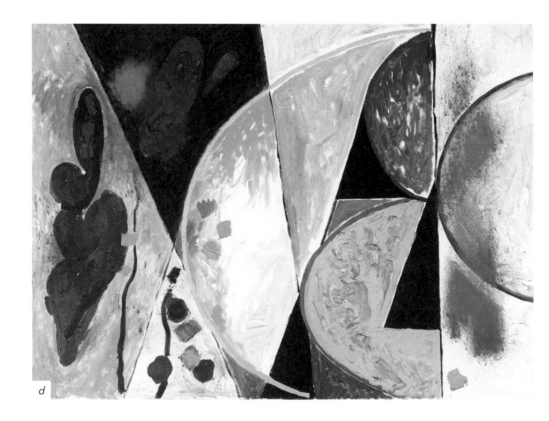

d

A SHORT BOOK ABOUT PAINTING

Problems started to emerge as I introduced what might be called biomorphic forms – vague references to foliage or the shape of hillsides (d). The problem here is bastardy, introducing different modes of painting which don't belong together into the same picture. So here you can see me making a basic mistake even at the time of drawing (e).

e

I think I more or less saved this particular picture by thinking very hard about deep winter colours in North London. In fact, the end product, using a lot

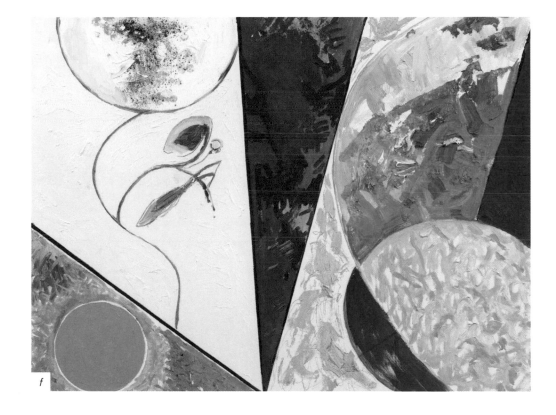

f

of white paint, and vivid reds, composed both of pre-prepared cheap paint and thrown pigment, worked well (f). But that, frankly, was the kind of luck that happens sometimes in the studio.

Now I come to the heart of this particular story – why a painting, despite a lot of hard work and close attention, can go spectacularly wrong. I was still thinking about these walking pictures and was starting to make a much bigger one, set in Camden, North London where I live, and reflecting on the disruption and the damage to the fine structure of the place likely to be caused by the tunnelling for the new high-speed rail link to Birmingham. I wanted a very strong and tense underlying structure (g).

The moving, or striding semicircles, with their own clear rhythm, are confronted by the botched circles on the left, and the plane is divided three ways by the diving triangle: diagonals always tend to produce a sense of insecurity in a picture. Using "urban" purples and blues I hastily filled in some of the right-hand side of the picture (h).

But, given the subject and the mood I wanted, this already seemed a little gentle, and so I added jagged dark shadows or triangles at the bottom of the lower curve, which immediately changed the mood (i).

But what of the all-important centre of the picture? I wanted to represent the strength of electric light, the energy and the intricate beauty of urban streets, and did so using pastel crayons overpainted with linseed oil – a deliberate contrast to the flat painting on the right.

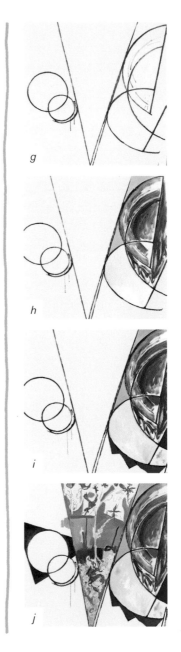

g

h

i

j

A SHORT BOOK ABOUT PAINTING

I wanted the colour and mood of the streets, not their literal representation, but as I worked, the shapes became far too specific, and as I hope you can see, the overall effect was revolting (j). Realising I was in trouble, I completed the rest of the picture using dark urban browns, reds and greys – I think relatively effectively.

k

There are, I hope, interesting passages of painting in this version (k). The maroons and greys and the deliberately unfinished, sketchy circles on the left, and the original pushing blues, purples and whites on the right get more or less exactly to the theme of the picture and the motif I wanted. But the centre is an abomination. Why? It's not just that the colours are unappealing: they are meant to be – they are there to describe something jangling and essentially disturbing. It's more that the shapes that have emerged virtually by themselves are, again, neither one thing nor the other – not simply representations of paint in paint, or yet drawings of anything in particular. I have stupidly mingled different ways of seeing on the same picture plane and at this point there is no way forward but to start wiping poor work out, and beginning again.

In the studio, a lot of what happens is obliteration and repair. In this case the first thing I had to do was wipe out the overemphatic shapes in the central V. I did this by over-painting with white, while leaving flashes and fragments of the original painting still visible. Second, I somehow had to ground the picture – there were too many lines and

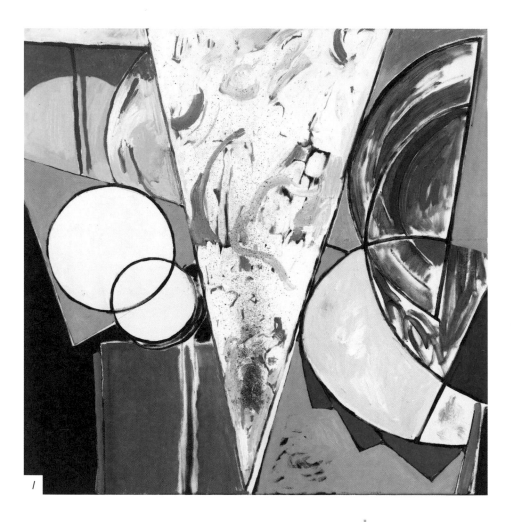

/

semicircles jumping around in too many directions.
So I introduced an icy blue, tying together the left
and right of the picture behind the centre (l). And
in this way I saved it.

Or at least, I think so. But it's worth noting
that the picture has become a rather different one.

A SHORT BOOK ABOUT PAINTING

It's still about the experience of walking through Camden during the winter of 2016–17. But the centre of the picture, instead of representing urban grime, now has a feeling of warmth and human colour. And the blue relates to one of those invigorating, vivid, very cold days we had so many of at that time. It has become a more optimistic picture, and a different picture.

m

Here is one final example from the same series, shown because it presented me with some hard problems, and again, problems essentially of motif (m). I wanted to paint about a walk in Cornwall over the New Year, when the greens and browns were particularly vivid, the sea was lashing and the sky was menacingly white. As with the previous picture, I started off with a pretty simple piece of underpainting.

n

There was a landscape feel to this, clearly – the parabolas on the right were no longer simply about moving across the surface but referred to, however simplified, the shapes of fields and hills (n). On the dark left-hand side of the drawing you can see a rock coastline below a moon. The central part had to serve for the ominous, white yet menacing sky. I set to work pretty fast, essentially doing a colouring-in exercise, though trying to keep different textures of paint visible as I went.

There are some good passages of painting in this, from the central, scored sea to the purplish clouds above it. But there are problems of motif and composition that I hope are obvious. The giant

circle to the centre right is too dominating, too flat, perhaps too big. And, worse, given that I have used naturalistic muddied greens and browns and purples for the fields, what is the relationship between an abstract red circle and what lies below it? Is that a horizon line towards the bottom of the picture? And what is the second circle really doing on the left? In the drawing, it's clearly there for balance, and to remove any sense of the red circle being a direct representation of the setting sun – in other words to fool the eye. But now the colours have been worked in, it doesn't fool the eye; it just irritates it.

The problem here is that I'm not sure whether I am painting a picture about the experience of going for a walk or whether it's really a stylised landscape. It can't be both. In the end, it came down more to the first. This is the final version (o). At least for now. The suns have become telescopic holes, punched through the landscape, and the unresolved gloom on the far left-hand side has been painted out with blues to answer the blues on the right. And I'm not at all sure whether I've improved it, or ruined it.

Over to you: but at least I hope I've given an honest account of what goes on in the place we're visiting next, the studio.

o

5 IN THE STUDIO

In all of the books I have read about painting and painters, there is almost nothing about what, to me, is the big reality and mystery – *what happens in the studio when a picture is being made.*

I don't mean gossip. I don't mean whether or not somebody else is mixing colour or cleaning brushes, if there is music playing, or the artist has had a drink. There is a certain amount of studio gossip, just as there is gossip about what happens backstage in a theatre.

But what we are talking about here is eerier – what is going on in the mind of the picture-maker, as he or she confronts an empty surface, then an increasingly busy surface, and tries to work out what marks to make.

It isn't movement. Gillian Ayres says that she spends a huge amount of time simply sitting and staring, rather than actually applying paint. Howard Hodgkin, according to rare film of him at work, is in the same boat and I suspect that, in fact, for most painters the real work gets done mentally – just looking and thinking. David Hockney speaks about "eyeballing", the swift movement of eye up and down from a subject, before the hand starts work. But non-figurative painters do something similar. So what are they looking for, and why?

What's actually going on in the mind at this point? With the obvious apologies for not being a "real" or professional painter, all I can say is that as I'm looking, I'm almost deliberately losing focus, choosing to let my consciousness go skittering helplessly around... until I hear myself thinking: "That whole upper third must be painted out with light blue" or, "There needs to be a thick black line running down the red on the right-hand side".

These thoughts, dredged up from the subconscious, seem instantly obvious and necessary, and propel me back towards the painting. Sometimes, I see much later, they were absolutely wrong. There is nothing infallible about the unconscious. But I think there are some innate feelings about colour, which I have discussed already, and motif (ditto), and composition. In other words, I think that most of us share under-discussed ideas about which paintings work and which don't.

Shape and structure

I'm now talking about something different from
personal taste or fashion in art: I'm talking about
substructure. At this point, most art manuals start
to talk about "the rule of thirds" or the golden mean.
The mathematical formula is: "a plus b is to a, as a
is to b". In practice, as used by Mondrian and other
modern artists, this deploys crucial lines on the
picture plane slightly more than a third away from
any particular edge; throughout art, painters have
used hidden triangles, rectangles and pentagrams to
express this allegedly beautiful ratio. Mathematicians
from Pythagoras onwards have been fascinated by
the golden mean, or golden ratio, which does indeed
recur frequently in nature, in the foldings of leaves,
for instance, or the arrangements of branches. But
it's easy to be carried away by something so neat,
and studies of a huge range of paintings suggest that
most artists don't actually follow the golden mean at
all. They probably work by instinct, and quite often
come somewhere close.

And that in itself is interesting. There are very
many paintings which simply have an object or
motif right at the centre, and leave it at that –
how many portraits are composed that way, for
instance? But in a less representational picture,
or in a landscape, for some reason the eye revolts
against neat bisection. I have in my hand a book of
Monet landscapes, and very rarely is there a strong
vertical or horizontal right at the centre of the
picture. Where there is, the composition feels

uncharacteristically lumpish and unattractive (sorry Claude).

Mostly Monet pushes the horizon line or the central division – which might be vertical, in a scene of trees – to not-quite-exactly a third of the way up or along; and almost everybody does the same. What is it about this proportion that is so very satisfying?

Could it be that as vertical bipeds we are used to constantly moving our heads? We must scan the landscape in front of us for signs of danger or food, while periodically checking the sky (particularly if we live in northern Europe). Sometimes, as the day is ending or beginning, or some important weather system is moving in, we are concentrating above the horizon, rather than below it. It's about the tilt of the skull on the spine – two-thirds, one third; one third, two-thirds. Could it really be as simple as that? I don't know but I haven't so far heard a better explanation.

Like all rules, it is there to be broken. One of the most sophisticated and witty masters of composition was Henri Matisse. In his famous *The Piano Lesson* of 1916, which is for me one of the most beautiful things ever painted, he put a bold light-blue vertical line almost (not quite but almost) down the centre of the painting. But by connecting it to a thicker vertical blue and then to a light orange, he jerks it towards the right of the picture and the golden mean. Further, by concentrating much of the action – the piano-playing boy and the attentive, slightly forbidding, seated woman – on the right, leaving left of the plane emptier, he achieves a completely satisfying composition. The flurry of the vertical lines towards the bottom of the picture plane – the blacks on pink and the blues on green – all converge around the golden mean, or something like it. Matisse is playing with us – playing with our expectations about composition – very successfully.

THE PIANO LESSON.
ISSY-LES-MOULINEAUX,
LATE SUMMER 1916
Henri Matisse

Another way of subverting the "rule of thirds" is to ensure that one part of the canvas is so thickly painted that we frankly don't care exactly where the division appears. Joan Eardley, the 20th-century Scottish painter, made a series of pictures of the sea off the north-east coast, some of which are indeed divided – horizontally – about halfway up. But the frenzied brushstrokes and loaded paint of the bottom half so dominate the more thinly painted skies that she gets away with it.

Very much the same was done by Robert Rauschenberg at about the same time in his picture *Rebus*. Painted on three panels, it is dominated by a horizontal composed of small vertical colour swatches, as if from a paint manufacturer's catalogue. But almost all the action of the picture – including clippings from comics, slashes of white paint and dripping slabs of maroon – is hunched above the line, most, but not all the way to the top, because that would be too blatant a division. Below the line are only the thinnest of scribblings, dripping paint and blank grey-brown space. It's a brilliant example of the use of thirds.

Of course, there is much more to composition than this. The picture plane is a limited surface and the eye will naturally speed towards its centre. To make sure that the viewer doesn't simply look all in one place, the painter needs to aim away, but subtly. Centre, but not dead centre. In front of an interesting picture, the eye will keep moving. But this means, in turn, that the edges of the picture will become a zone of anxiety – is

everything falling away towards them? Where is the
coherence? This is about colour as much as shape.
And again – just because he seems to me the most
important painter since Pablo Picasso – overleaf is
another Rauschenberg example, this time from an oil
and silkscreen print he made in 1963.

Note, first, how he deals with the centre of the
picture. The teetering white building, central to its
theme of city chaos and near collapse, pulls over to
the right. But the picture remains centred because

REBUS, 1955
Robert Rauschenberg

of the savage slashes of red and yellow around the
"stop" sign just to its left. Above it, the remains of
a street lamp divides the picture vertically almost
a third, not quite two-thirds, as the eye likes.
Rauschenberg only bothers with a little bit of this
and lets the viewer complete the line internally.

Now let's focus on his use of colour. The reds
and yellows, which are dominant, run from small
blocks in the top right down to the bottom left in a
rough diagonal line. Diagonals tend to signal danger
or uncertainty, and this is part of the meaning of the
image. If New York is an estate, it's one in very poor
order. But had he left that diagonal as the only
colour theme, the whole picture would have felt
very unbalanced. So, alongside the strips of blackish
screen-printed images of buildings running down
the right-hand side of the picture, and then along
the bottom (and ending with the Statue of Liberty
seen from below), he has used patches of cobalt and
ultramarine blue. The effect is to create a reversed
L shape, which literally underpins and holds the
rest of the picture together. It is so strong that
Rauschenberg can allow the left-hand side of the
picture to dissolve in kaleidoscopic patches of
yellow, white and grey. He has perfectly resolved
both the problem of the edges and of the centre;
but I bet he did so almost unconsciously.

There are many other ways, clearly, of composing
a picture surface. Richard Wright is a Glasgow-based
artist who in 2009 won the Turner prize. Although
he has produced "traditional" abstract paintings,

ESTATE, 1963
Robert Rauschenberg

he is now best known for painting directly on to walls in different locations, making art that is designed to be scrubbed off again or to decay – deliberately ephemeral work. It's an interesting response to the ruthless commercialisation of the modern art world. Wright says: "It's not so easy for the work to be absorbed into the market... The work is not for the future, it's for now." His painting, which can be small in scale or very large, involves elaborate rococo patterns, meshes, the repetitions of lozenges and dashes in intricate, often gold, very beautiful forms. Because it's not made on a board or canvas which can be moved around, but on walls or ceilings, or behind bookcases, Wright doesn't have to worry about the problems of centring or edges, or not nearly so much. His composition is much closer to that of traditional textiles – Moroccan carpets for instance – than to composition as Matisse or Rauschenberg would have understood it.

What Wright proposes is that we could think about painting completely differently, getting away from the easel and the canvas. He is not alone. Richard Long, the British environmental artist, has made ephemeral spiral pictures using mud handprints on gallery walls. We will return to this later, looking at the big problem of the art market today. But all that needs to be said here is that composition is one of those things any conventional oil painter will be thinking about relentlessly while sitting in the studio, staring, apparently vacantly, at an empty canvas or a failing one.

The help that's at hand

If struggling artists are looking for specific help,
of course, there is plenty at hand, though much
of it turns out to be just selling by another name.
An excellent magazine, *The Artist*, is one of many
that offer practising painters monthly advice about
which crayons to try, how to cope with shadows
quickly in watercolour, how to represent a fast-
moving crowd, waves breaking, or whatever. The art
industry constantly presses upon practising painters
new sets of colour sticks, new brushes, new surfaces,
all with endless handbooks. Websites like that of
Keiko Tanabe, a popular watercolourist, constantly
update painting enthusiasts with tips and ideas. We
are surrounded by affable, self-deprecating gurus of
the sable brush.

But what these sources don't help with, in my
experience, is the fundamental problem: what should
a painting be? They tend to assume that mouth-
meltingly beautiful views of the Venetian canals,
street scenes in Nice, or the Appalachian hills, are
what's needed. Yes, really: yet more of all that. We
can all admire the virtuoso technique of a top-rate
conventional portraitist, or the photorealist who uses
tiny airbrushes to make an image of a chain fence
around an abandoned mid-American gas station, so
accurate that you initially assume it's a photograph.
I'm not knocking this stuff, which is all around us.
It just doesn't bring the heart into the mouth, or
make the hairs stand up on the nape of the neck.
Or not my heart, mouth, hairs and neck, anyway.

Almost all amateur painters want to improve, and that's a good thing. They may start off making badly drawn and implausibly coloured images of Devon cottages, and be determined to work and learn their way to doing the same thing much more proficiently – so that we "believe" the shadows on windows, and nod with recognition at the shape of trees and the yellowish crud on the bottom of November clouds. This is all fine.

This is what an influential section of the art industry wants us all to do – a patient upgrading of skills and observation that raises really bad painters into perfectly acceptable, house-trained image-makers who do no harm. But, although "do no harm" is a good starting point for a doctor or nurse, and a lot better than the alternative, it's not really good enough for painting.

It suggests that painting is like baking or knitting and that with enough practice and dexterity and close attention to process, you will be able to produce a good picture of the Thames at sunset, just as you will eventually, after a lot of smoke and cursing, learn to produce an almost perfect Victoria sponge. It will be harmoniously balanced with convincingly falling shadows, composed of mixtures of ultramarine and umber (the Thames, not the sponge); the horizon line in exactly the right place; and the details of buildings and shipping indicated, but not drawn in with irritating and confusing detail. You will have learned your lessons, and learned them well.

I'm aware that by now I will have infuriated quite a lot of readers, who will be thinking, "and what the hell is wrong with that?" Nothing. Learning to look really closely is good in itself. You cease to take the beauties of the world for granted and you sharpen your intelligence. Just as learning to listen to complex music is good for the brain, I am sure that learning to look closely is an incontrovertible good.

Similarly, as a craftsman, learning how to use, clean and exploit your materials is a damned sight better than bodging. I'd rather go around a local art show whose members understand oil paint and linseed oil, than one whose members thwack on the acrylic and can't draw.

Better is better. But I come back to the problem that only a few paintings or painters actually rock you, change the way you think, make you see and think about the world afresh. Competent, conventional art may be good for the artist but it doesn't much help the keen-eyed and avid art lover.

To say that isn't being elitist. Think again about the huge crowds that force their way into towns to come and look at work by the big names of today – Gillian Ayres, Bridget Riley, Howard Hodgkin, Anselm Kiefer, Frank Auerbach, Georg Baselitz, Gerhard Richter. These are not, by and large, "easy" painters who have worked their way up through magazines and websites. But they have all asked fundamental questions about what pictures should look like now, and why, and as a result they have set aflame the imaginations of millions of fellow humans

and – a really trivial point for which I apologise in advance – set new records for the prices of their work. Interesting new painting compels attention. Even if hundreds of thousands of hard-working, attentive people learn to paint the light on a Venice canal not quite as well as John Singer Sargent managed to do in 1904 – and that is a very high bar – they won't change our imaginations a jot.

Humankind absorbed those pictures long ago, swallowed them down, digested them. They lack the one thing that all great painting requires, fresh freshness. The argument of this book is that to get there, you can't travel via the conventional high road of good painting. You have to push away the easy messages, the solutions that have emerged from centuries of practice, and work and think harder. Inevitably, most of the time, you will be making mistakes. Sometimes, they will turn out to be the right mistakes, and take you through a door you didn't know existed.

But if only it was as easy as that.

Every time I set up a blank canvas or a blank piece of paper, I experience the same feeling – queasiness, something approaching panic, and a profound lack of self-belief. There are a limitless number of marks that could be made, and almost all of them will be mistakes. That is, they will set up a logic which will lead the picture towards banality or pointless mimicry. For every mark implies another. Will that circle be repeated or answered by a different shape? Will it be a sun,

a plate, a face? That stuttering horizontal line – it's the sea isn't it? Or if it's not, you'd better work hard and fast to make that clear. And so on.

One of the reasons painters tend to develop a signature style and stick to it is that this helps answer the original panic. Some people will always begin with an image at the centre of the picture plane. It seems that Picasso mostly does this – a face, a bird, a group of figures, will shoulder themselves out of the centre, and the lines will press away towards the edges of the paper or canvas. Other painters think very hard about the edges, and work inwards. Oddly, because his pictures mostly involve a central shimmering block of colours, I think Mark Rothko probably painted that way. But an initial, bold decision about how to break up the picture surface, and – to put it banally – what will go where, helps any painter get going. And once you have a way in, you are likely to use it again and again; and that way in will hugely influence what's going to happen next.

The final thing I'm always thinking about when I'm staring at a possible picture is balance. You want the eye to move around the picture surface, and that means it's better to set up echoes, or correspondences, in shape and colour that encourage the eye to keep moving. But if there's too much balance, like a perfectly matched tug-of-war contest, the picture becomes static. On the next page is a little picture of a seaside garden, partly in homage to Patrick Heron, who at the end of his life loved the combination of yellow and violet I use on the far left.

The different systems of balance are, I hope, pretty obvious. You have the vertical violet and yellow columns down the left, answered by orange and green columns on the right – not too balanced and therefore differently sized. The axe shapes on the left are met by the primitive boat-like orange eruption on the right. The brown/dull blue diagonal below the shark fin or boat is matched by the sky blue diagonal above it; the violet circle and the blurred orange circle observe each other.

HIGHLAND GARDEN
Andrew Marr

A SHORT BOOK ABOUT PAINTING

I don't claim that this is a particularly profound painting, and its subject is only the emotional experiences of being outside on a particular day surrounded by vague thoughts of ancient days that I couldn't write down in words. But it's a good example of the problems of composition: if you took away a single one of the elements I have listed, the whole thing would collapse and be nothing but an incoherent mess. It holds together. Just. It nearly didn't. And that's what goes on in the studio.

6 PAINTING NOW

What are paintings made from, and why?
The artist Antony Gormley has said that all art is
made for the future. By that he might mean simply
that innovative art is often not understood during
the era when it's being made. It takes time for
people to get used to changes of direction and fully
appreciate their point. But I guess that Gormley
meant something subtler – that art is a message,
thrown from the present into the future – *hello, you,
this is how it felt for us.*

Proper art is about wrestling with the here and
now, more than it is consciously pitched forward;
but authentic accounts of any kind will be interesting
when the artists involved are long gone. Art that is in
any way serious will reflect the conditions in which it
is made.

So what, in the teenage years of the 21st century, are those conditions? We live in a pessimistic age, and one of accelerating change, in which we are expected to be scared about climate change, terrorism, growing inequality, shrinking biodiversity and much more besides. Art which reflected that would be angry and pessimistic, and carry within it some sense of things careering out of control: and from Jake and Dinos Chapman, to Gilbert and George, to some of the work of Damien Hirst, there are indeed plenty of examples of this kind of art.

But we also live in what you might call *the age of new toys*. We are digitally informed, digitally entertained and often digitally employed generations. We are drunk on virtual reality and we are hooked on contemporary technologies – even if we are also

HELL, 1998–2000
Jake and Dinos Chapman

uneasily aware that the robots may be coming for our jobs. And our increasingly omnipresent digital surroundings also have a direct effect on contemporary art. They are part of the times we live in, reflected in the increasing use of digital film and computer drawing, including by artists such as Michael Craig-Martin.

Nothing very new there, you might say. Some of the biggest changes in art have been in response to technological innovation. David Hockney has written passionately about the impact of better lenses, better grinding and photographic boxes on the work of artists as diverse as Caravaggio, Vermeer and Ingres. More recently, during the late 19th and early 20th centuries when chemical photographs arrived to challenge original, handmade art, artists reacted by trying to make their work as little like any possible reproductions as they could.

The "eat me" stippled and blurred brushwork of the Impressionists and Fauvists showed the importance of breaking away from the smooth surfaces of academic painters – photography could do smooth surfaces and brushless effects far better than they could. Next, the Cubists and later the Abstract Expressionists, responded to photography by making images that broke further away from immediate, easily apprehended reality – images that photography couldn't have imagined.

Today's digital revolution takes this old argument much, much further. First, digital manipulation means that photography has chased after the artists

UNTITLED (GROUP I), 2017
(ACRYLIC ON ALUMINIUM)
Michael Craig-Martin

and caught them pretty easily. It allows endless
"effects" – copies, variations, improvements,
blurrings, stipplings. A relatively simple computer
program can be used to turn an image of a
Tokyo street, or your neighbour, into a "Van Gogh";
Picasso's distortions can be mimicked by a child
in a bedroom with a touchpad or a mouse.

But second, the digital world is global and almost
seamlessly interconnected. It obliterates the local.
Contemporary artists are responding to both things.
They have been concentrating on the material
fabric of their art, creating "real-world" pictures
and sculptures that are a conscious rebuke to
digitalisation – art made from mud, wood, fabric,
lead and ice. Third, in the midst of economic and
cultural globalisation, the most interesting art has
been defiantly local or national – today's great
German painters are very Germanic, while the

A SHORT BOOK ABOUT PAINTING

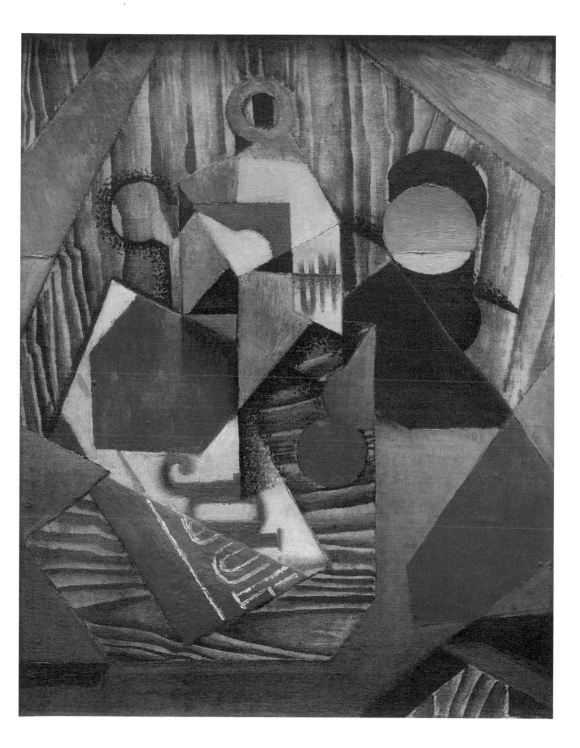

art of Tokyo and London is at least as far apart in tone and feel as it was in 1870.

In short, there is an artistic counter-revolution going on which, because of the fashionable nature of the art world itself, has not perhaps been properly understood.

Let's start with the material fabric of contemporary art. Robert Rauschenberg was one of the great American originals, a man whose interests and ambitions flared in many directions, and whose influence on today's art has been underestimated. As I suggested earlier, I think he may be the most important painter since Pablo Picasso.

Most of his work is the opposite of a glossy, smooth digital surface, though he did make screen-prints. In any exhibition or museum, the labels traditionally give the viewer the same basic, essential information – the name of the artist and the piece, its date of creation, and what it is made of. "John Fuller, *Portrait of a Man*, 1948, oil on canvas" – that kind of thing. Well, here is the equivalent from the Tate exhibition for Rauschenberg's 1955–59 work *Monogram*: "oil, paper, fabric, printed reproductions, metal, wood, rubber shoe-heel, and tennis ball on two conjoined canvases with oil on taxidermy Angora goat with brass plaque and rubber tire on wood platform, mounted on four casters..."

That is an extreme example but other more conventional-looking works involve, we are told, "cut-out compartment containing four Coca-Cola bottles... And unidentified debris" or "glass, mirror,

tin, caulk, a pair of the artist's socks and painted leather shoes, dried grass and taxidermied Plymouth Rock hen", or "oil, pencil, toothpaste, and red fingernail polish on pillow, quilt... and bed sheet mounted on wood supports."

This sounds just the kind of thing that haters of modern art love to laugh at – typical London metropolitan 21st-century rubbish. So the first thing to be said is that these are works made quite a long time ago, in the mid-1950s; and the second, is that they are all extremely beautiful. Rauschenberg had an almost uncanny ability to scatter shapes and colours across the surface in a way that forces you to stare, and finally makes you grin with delight. So why was he importing taxidermy, articles of clothing, pieces of metal and rubbish into his paintings? In part, he was interested in making art in three dimensions out of the debris of contemporary New York, where he was then living.

But he was also making pieces that are impossible to reproduce, because they depend upon "real stuff". The result is that you absolutely have to go and see them in person to understand what he was doing. He can't be understood from books. Or, indeed, from computer screens. He ditched canvases in favour of wooden supports because he could nail or drill through them to introduce foreign objects to make them thicker and more complex. These are pictures which, despite the high quality of the art catalogue that came with the show, are completely impossible to reproduce. They are much more,

almost defiantly, themselves than 99 per cent of modern painting.

There is virtually no such thing as a completely new idea in art and Rauschenberg learned a lot from the German artist Kurt Schwitters.

One of the modern artists hated by Hitler, Schwitters fled Nazi Germany to work in Holland, then in an internment camp on the Isle of Man, before at last ending up in the English Lake District. A true original, he experimented early on with collages composed of torn pieces of scrap, matchboxes, bus tickets and discarded fragments of painted wood and glass. Some of his experiments were more successful than others: sculptures made in the Isle of Man from porridge quickly turned to foul-smelling mould. But the bulk of his collages, many of them three-dimensional, are breathtakingly beautiful. They are some of the most gorgeous objects ever made by a modern artist. Schwitters always regarded himself as a painter, though one who "nails his paintings together"; he called his technique *Merz*, a made-up name which came from a fragment of paper used in a 1918 work which had the German word "Commerz" printed on it.

His work has survived not because of what he made it from, but because of his innate feeling for colour and composition. But the way Schwitters made pictures has been hugely influential. First of all, if you have a slight three-dimensionality on the picture plane, then it constantly changes, as the light source shifts. It can't be entirely static. Subtle

above
KURT SCHWITTERS, DURING RECITAL OF HIS "URSONATE", LONDON 1944

right
MERZBILD ROSSFETT, 1918–19
Kurt Schwitters

shadows alter the composition at different times of day: in the age of film, art was moving away from the notion that a picture is always the same thing once it has been made.

Second, his use of scrap and found materials was itself a challenge to the pomposities of high art – Marcel Duchamp was the other great innovator here, though I think the lesser artist. Finally, because the found materials came from popular culture, these were pictures that helplessly carried the impress of the place and time of their making. They include Berlin bus tickets, or adverts for chocolate peppermints in 1940s Britain, or a fragment of a label advertising a long-forgotten exhibition. Schwitters might have been a transient, international artist, but he lived and created very much in his here and now.

A much more famous German artist shows the power but also the limitations of these ways of working. Joseph Beuys was born under the Nazis and fought in the Second World War as the gunner in a Stuka dive-bomber. When his plane crashed in the Crimea in 1944, Beuys survived – he said, because he had been found in the snow by Tatar tribesmen who wrapped him in animal fat and felt as part of the healing process. Records suggest that in fact Beuys had a much more humdrum rescue and was discovered by a German rescue party, there being no tribesmen in the area. Even so, he used this memory, or fantasy, throughout his life in art, deploying rolls of felt, sticks, pieces of basalt rock, sledges and much more to create a kind of epic

spiritual story. He inserted himself as a kind of
shaman in the modern art story.

Beuys's position is paradoxical. He was
undoubtedly one of the most influential artists of
the second half of the 20th century, famous in every
major city and exhibited all around the world. His
ponderous self-importance and rather grim style
have been copied by hundreds, probably thousands,
of lesser figures. And yet, in terms of public affection
and a living, vital tradition, his art has not taken off.
Animal fat and felt are admirable materials, but art
is more than stories. Without a sense of beauty, and
skill as a communicator in shape and colour, even
the most ambitious innovator is bound to fail. Today,
Schwitters is more alive than Beuys.

His work has great relevance for painters in the
teenage years of this new century because it insists
not only that art can be made out of anything – not
only that it must be material and specific – but also
that it must grab you by the throat. What cannot be
devoured by the digital revolution? The smudgy,
aromatic nature of charcoal. The random clagginess
of heavy oil paint. Sticks. Stones. Broken bones.
Dust. Stink. In short, the materiality of life. But
what must art also be? That unfashionable but
essential thing – beautiful.

Many of the most interesting contemporary
artists feel the same. In an interview published by
the Royal Academy magazine in the winter of 2016,
the painter Aimée Parrott, in conversation with Basil
Beattie, defended what she called the directness of

painting made by hand and without new technology. She liked, she said, the "material presence of a painting, its fragility and yet density – its sense of layered time which benefits from a long slow look in order to unfold – in contrast to the slipperiness of the sanitised, disembodied image on a screen hastily scrolled through. I think this makes painting seem out of step, makes it stick out and sets up a very interesting tension between two very different modes of looking and experiencing..."

The issue could hardly be put more clearly. Beattie agreed with her, pointing out that work made by hand involves trial and error, emotion and happenstance – all, of course, part of being alive. He told a story about a group of American painters being asked by a critic what it was like when they went into the studio. One of them, Philip Guston, answered by quoting the composer John Cage: "The studio is full of other people, and as you begin to paint, the people begin to leave, one by one. And if you're really lucky, you'll leave." This sense of awe, and delight in the contingent, is pure Kurt Schwitters.

Rauschenberg said of Schwitters that he felt he had made everything "just for me" and many other artists have felt the same delighted recognition when encountering the art of this genial, modest German genius. In 1967, the Italian art critic Germano Celant coined the term "Arte Povera" for a wave of radical Italian art making. Celant himself made sculptures out of wire and human hair. Others in the movement used logs, sticks, ropes, mounds of

old clothes and discarded industrial rubbish – and even, in one notorious case, the artist's own excrement, carefully encased in metal tins. In all this, we are getting a long way from painting, the subject of this book, and towards assemblage, performance art and conceptualism. But the basic point is that by using objects from the real world, contemporary artists can defend themselves against the overwhelming wave of digital imagery.

We see this still, running riot in contemporary Britain, from the "YBAs" or young British artists (though they no longer are young) through to environmental artists. Think of Hirst with his cabinets, his pickled shark and his flies emerging from rotten meat only to be electrocuted. Think of the satirical-erotic work of Sarah Lucas, with her buckets, fried eggs, stuffed stockings and suggestive fruit.

Think of the work of Richard Wright, the ephemeral, delicate painting on walls, destined to be scrubbed off again, or Richard Long and his mud paintings. Think of Andy Goldsworthy, who makes exquisite sculptures out of fragments of ice, brightly coloured autumn leaves pinned together with thorns, teetering assemblages of stones, or wall-pictures from mud.

Of course, there is a paradox in much of this art. Sarah Lucas, defiant fag hanging from her mouth, found that most of the work had to be photographed to be disseminated. She couldn't sit forever with her fried eggs on her chest, so the work is known now entirely from reproductions.

Goldsworthy's art melts, decays or is blown over – that is in the nature of what he does. Very few people can experience a Goldsworthy sculpture in the flesh (and the snow, and the woods, and the puddles). Though I find it very fine and moving, this art too can only be understood generally in reproductions in art books or occasional gallery shows, again often as photographs of the original work.

So does this mean that the breakthroughs established by Kurt Schwitters must disintegrate and vanish as well? That, in the age of digital reproduction, art made out of the crumbling materials of life itself, as a response to technology and a global market, can only be enjoyed through digital reproduction?

Well hold on. What about the art of Schwitters himself? You can still see that. You can walk into galleries all around the world and enjoy his assemblages, paintings and drawings still as bright and fresh and immediate as on the day they were made. The best response to the cold digital present is painting, that old and simple practice.

The country that has dominated contemporary painting more than any other over the past couple of decades is not the United States but Germany, and among the best-loved German artists is Anselm Kiefer. Younger than Beuys or Schwitters, Kiefer was born right at the end of the Nazi era. His work confronts German history much more directly than either of theirs does but, like Rauschenberg, his kind of oil paintings had never been seen before.

A SHORT BOOK ABOUT PAINTING

He isn't only a painter. He has made massive, wood-bound books, huge metal sculptures, stark, gigantic woodcuts, fantastic works of architecture, and vitrines that hold dresses, fragments of trees and feathers. But it's the paintings that hold the viewer most directly. Whether his subject is the ancient cities of Mesopotamia, with their brick ruins and messages about power and civilisation; or the endless German plains; or wartime dogfights; or dragon-haunted Teutonic forests; or the optimistic uplift of sunflowers and cornfields, Kiefer's paintings are big in every direction.

They sprawl across gallery walls, forcing the viewer to keep walking backwards to see them properly. But then you are tugged closer to them again, to stare at the thickness of the paint almost falling off the backing, and the savage, scored lines through the paint. This is not paint that represents bricks, or the rutted surface of a field. It is, apparently, paint that has *become* bricks, or mud, or human flesh. As with Rauschenberg's work, there are objects inserted into the surface of the picture – they might be model ships made out of lead, or real pieces of corn, or industrial diamonds. Some paintings include glass cases, so that woodland might be both painted and represented by real twigs and sticks.

Again, as with Rauschenberg, it is possible to take photographs of Anselm Kiefer's paintings and reproduce them but they are really nothing like the real thing. You have to go and see them.

LET A THOUSAND FLOWERS BLOOM, 2000
Anselm Kiefer

In the course of this short chapter I find that I have chosen artists – Schwitters, Rauschenberg and now Kiefer – who have been the subject of recent exhibitions in London. There is nothing surprising about that. Good art can't be enjoyed at second hand, even in the most lavishly produced catalogue, and that becomes more true, not less, as artists rough up the surface of their work. The surface records the making, not just the subject.

Because Jackson Pollock's action paintings were a record of Jackson Pollock's balletic body movements, recording the size and shape of his arms, legs and torso, they were a record of something that couldn't be mimicked by machines. Scroll towards 2017 and the argument has become more urgent, not less so. The best art doesn't present a smooth, lucent shine to the world. It almost assaults the physical viewer.

Potent influence doesn't simply bounce from one genius to the next, like a ball being thrown. It ripples out and eddies and is found in unexpected corners, repeatedly and all over the place. Concentration on the material nature of painting, and leaving in the marks as a record of what was done to the surface, and an interest in the humble as against the expensive or elite – these are traits found almost everywhere.

Jason Martin is a London based painter whose work consists of a very thick pigment, in oil bound with poppy seed oil, or sometimes acrylic, slewed on to an aluminium base using a metal or plastic slider, so that the subject of the picture is the richly enfolded paint itself and incredibly sensuous. Even

UNTITLED (DAVY'S GREY/
TITANIUM WHITE/RAW
UMBER), 2016
OIL ON ALUMINIUM
220 x 178CM
Jason Martin

A SHORT BOOK ABOUT PAINTING

when he is restricting himself to grey and white, this is painting which, when you meet it, you want to eat it.

Another painter, a friend of mine, Adrian Hemming, demonstrates how this interest in the surface and the texture of paint can produce landscapes which are both recognisable and unlike anything done before. He grinds and mixes his own pigments and uses a wide variety of fixatives to get effects that again – I am glad to say – cannot quite be reproduced and have to be seen in the flesh.

So, I hope I've convinced you that one of the most important aspects of good contemporary painting is that it should react against the omnipresent, glassy, digital effect of most modern culture – that it insists on being itself. And a second, perhaps less obvious, quality is that it often derives from local circumstances, rather than from some nebulous, abstract globalised culture. In short, it is *real* and it is *local*.

But also, it ought to be fresh, even unique. I've listed a great many influential contemporary artists here, and this raises another question that everyone who tries to paint must confront: what is acceptable learning from the masters and mistresses, and what is merely plagiarism? There are so many examples of painting all around us, so many different kinds of experimentation running in so many different directions, that it's increasingly hard for an artist to respond to that simple-seeming injunction: be yourself.

WATER SLIDE, 2010
Adrian Hemming

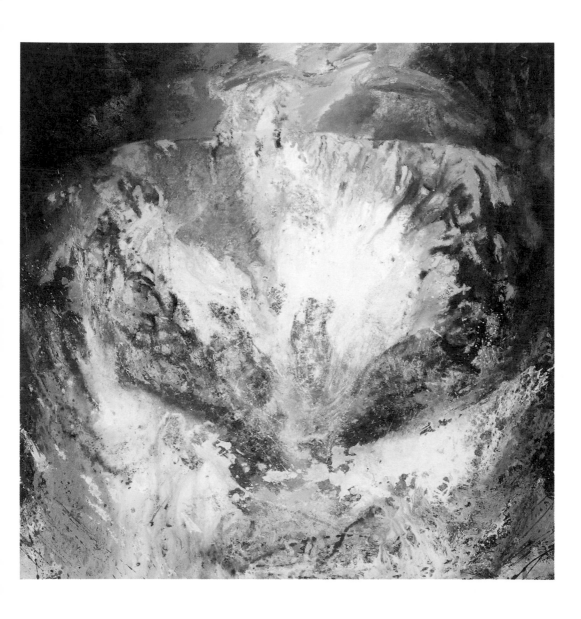

My answer is that no artist owns a technique, whether or not he or she invented it. Ways of laying on paint, unexpected mediums to mix with paint, the use of scalpels, masking tape, aluminium bases, or plastic boxes inserted on to the painting surface – all these techniques, or tricks, are available to anyone who wants to try them. I spend a lot of time ambling around looking at other people's pictures and trying to learn from them. Declining to try something out yourself because it has been done first by another person would be as logical as a guitarist declining to use newly invented pedals, or a film-maker rejecting a new camera. And artists tend to be magpies in other ways too. Including aspects of photorealism alongside much rougher painting was a trick used by almost all the great pop artists. As soon as Caravaggio demonstrated the powerful, visceral effects of a harsh overhead light source on the wrinkled, battered faces of the street, everybody was trying it. So far, so much virtuous learning.

But once an artist has painfully won through to find a unique way of drawing the world, swiping *that* for yourself is simply theft. The one thing you cannot appropriate is the vision. To make your own pictures using Roy Lichtenstein's cartoon spots technique would – rightly – invite ridicule. Other artists have copied David Hockney's sophisticated coloured pencil drawing technique from the 1970s. But it still belongs to him, and nobody else.

Somehow or another, it is the obligation of any proper painter to eventually make images which

belong to them, which aren't quite like pictures made by anybody else before, and which represent their own individual human view of the world. It's incredibly difficult. But it's also incredibly important because only then, and not before then, do you have the right to call the work your own.

And intellectual property matters, in turn, because of the bloody, grinding-down and increasingly depressing problem of art economics.

Following the money

Art materials have never been more handily available, probably never cheaper. The trouble is that images have never been cheaper and easier to obtain, either. In the Victorian period, an artist like Turner knew that there was an insatiable demand for coloured representations, big and impressive, to hang in the homes of the wealthy. But even when demand from the Earl of Oatcake and Lord and Lady Porridge was lagging a bit, Turner and his contemporaries could sell engravings in huge quantities – either to illustrate books or to hang in the houses of the less wealthy middle classes. Even in the 1930s, artists such as the East London group, painting smallish oil pictures of the streets and landscapes around them, could rely on a steady flow of customers wanting to decorate their lives.

But today you can get an excellent reproduction of almost any of the world's greatest art to hang wherever you want it. Only the super-rich still buy art as a form of investment and showing off. There aren't

many of them. Economically, the biggest shifts in past decades have seen wealth and power cluster around a small number of super-winners – look at the change in the distribution curve of income in the United States or the UK, for instance, over the past decade.

It's a common perception that in many fields, the gap between the hyper-successful minority and the unsuccessful majority has grown wider. Whether you are a Premier League footballer, a tennis player, a worker in banking or indeed a journalist, a very small number of people are now paid far more, proportionally, than they would have been in the 1950s or 1970s, while the majority find their real incomes are worth a lot less. Analysis of the average wages in major companies, compared to the earnings of the CEOs (Chief Executive Officers – or top knobs) suggests that in business at least this pervasive feeling is not merely a rumour. According to *Fortune* magazine, in a 2015 article reporting on an independent survey, "In between 1978 and 2014, inflation-adjusted CEO pay increased by almost 1000%…Meanwhile, typical workers in the US saw a pay raise of just 11% during that same period."

While I have no statistical evidence for this, my strong impression is that in art making as well, the gap between those earning fabulous fortunes and those just chugging along has also grown substantially. In early 2012, the American journalist Joy Yoon attempted to list the world's most wealthy living artists. Many of the names are indeed world-famous. David Hockney, Antony Gormley, Anish Kapoor and

Damien Hirst, who was the world's richest artist at the time, were all on it. So too were much less well-known artists who simply had the luck of having very rich patrons. Yoon argued that Hirst was worth around $1 billion, while Hockney, like the German artist Gerhard Richter, was worth $40 million.

The details, frankly, don't matter and are probably as much to do with shrewd financial decisions taken by successful artists as the original price tags of their work. Artists who are particularly interested in wealth understand that making prints, for instance, is an excellent way to boost their income: one well-known name told me recently that he could make more than half a million dollars very quickly by doing a print edition, and it was far more sensible economics than labouring away making original works.

If I compare this with the lives of professional painters I know who try to make a living by producing oblong canvases of representational or abstract work in oil, watercolour or acrylic, then it's frankly a different world.

These days, relatively few professional people – by which I mean doctors, teachers, entrepreneurs, office managers and the like – would think of spending several thousand pounds on an original artwork to hang in the lounge. Yet, to earn a decent living from painting, you need to sell works at several thousand pounds apiece, and you need to sell them relatively frequently. Price something at a few hundred pounds, and the world will take you at your very low self-estimation; you will have no chance of living on that.

A lot of this is about salesmanship and luck – finding an individual keen enough on what you do to keep coming back for more – as well as original talent. But if I didn't already have a full-time job as a broadcaster and writer, there is no way that I could afford to rent my own studio and spend so much time making paintings. I feel a little guilty about it at times: young professional artists must feel plagued by the lively and cut-price market in pictures by amateurs. If a computer programmer enjoys making delicate watercolours of city streets and sells them as a hobby for, say, £700 apiece, that may be disastrous news for the woman around the corner hoping to live from her paintings of similar scenes.

Of course, the artist starving in a garret is a stock cultural cliche; and painters as great as Van Gogh and Claude Monet lived at times in utter penury. But that was often because the starving artist was trying to make new, surprising and unfashionable art. There were plenty of ordinary, dull, fat artists as well. During the late 19th and early 20th centuries, artists could rely on a prosperous bourgeoisie to make a real market. That market is now smaller, not only because the prosperous bourgeoisie is proportionally smaller, but because of the disruptive effect of technology. Pictures are cheap. The super-rich compete for the works of a tiny number of globally famous, instantly recognisable art-makers, jostling one another in an obscure competition. Everybody else is scrabbling for coppers.

So what?

So what? That is the proper, emotionally mature response of proper, grown-up artists. Most full-time artists can think of doing nothing else and regard every hour they spend in a studio as a stroke of luck, time stolen from pointlessness. Painting has always been involved in the politics of power and money, from the high princes of the Renaissance, to the industrial barons of Boston and Minnesota. Painters have always been in trouble. But painting, proper painting, turns out to be as defiantly resilient as live music or poetry – an ancient art that revives itself in every human season. We have looked at the surrounding circumstances of contemporary art in different ways, from problems of technology and geography, to problems of money. It's time now, at the end, to ask again – what's it really all about?

7 IMMORTALITY

My wife and children ask me that. They find it odd
and, I'm afraid, slightly irritating when I trail off,
yet again, to the painting studio round the corner.
I should be doing something more normal, like
watching television, or eating buttered toast.
"What are you doing it for?" they want to know.

What is this compulsion to leave something
behind? What is this rather pathetic reaching
for some sort of immortality? The interrogative
banter starts to have an edge to it. Painting might
be a reasonable thing to do if you are a lifelong,
full-time and professional painter who can actually
earn a living by making pictures that people want.
For somebody like me, who has a perfectly good job
doing something else, it seems to smell of delusions

of grandeur. What *do* I do it for?

It's a reasonable question. It deserves an answer at the end of this short book. I am not completely deluded. I don't think I am Camden's Caravaggio, or the Picasso of Primrose Hill. I can tell the difference between great paintings and the rest and I know perfectly well that the pictures I make will never change the course of anything and may well be quickly forgotten just as soon as I shut up about them. I started on this journey far, far too late in life. There *are* important painters. I am not, and to my eternal regret, will never be.

Yet there is something inside that seems to have to fight its way out. What it feels like to be me and alive now is something I want to explain, and I can do so only through paint. I'm in my late 50s, not particularly well, and time is running out.

And I know enough to see that sometimes the pictures are successful as communication and sometimes they aren't. The ones that work are postcards. They are messages sent outside my immediate circle of friends and family, and even into the future. And all I really want is that they stay alive. I certainly don't want them to be inflated carriers of wealth – paint and canvas investments the price of which spirals ever upwards.

I want them to be conversationalists, smiling, gregarious yet silent talkers on the walls of private flats and houses, and perhaps public spaces such as schools, nursing homes and hospitals. I want them to speak to people I have never met and never

will. That is, I hope people will stop in front of them and find something that catches their attention, and provokes questions and a musing half-smile.

For mysteriously, the thought and passion and work that goes into an oil painting can be caught on its dried surface – and then released, time and time again, as energy to the viewer. If I go and look at a picture by Peter Doig or Patrick Heron, something of what they poured into it in remote places or long ago, floods into me. Immortality, importance, a place in art history are all, no doubt, wonderful things, but the real point is a transfer of energy.

Often it doesn't happen. Paintings don't all live. On Monday, you can be putting your everything into a picture, thinking hard, working hard, and leaving the studio feeling that you have made something that earns its place, that's alive. And then you come in feeling chirpy on Tuesday… and the poor beast has died in the night. Yes, there are just the same colours in just the same places, but it's a dry corpse. If you hung it on a wall, you couldn't keep coming back to look again, except with mounting distaste and horror.

The line between this dead picture and another picture which, against all the odds, despite some terrible bodging and moments of despair, seems to stay alive, is a tiny, flickering thing. It isn't a line you can touch with your finger. But it's the fatal division between transcendence and boredom. It's the only thing that matters.

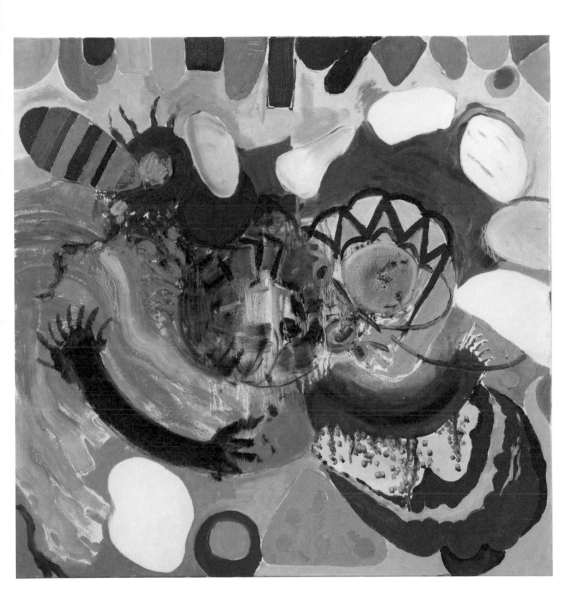

Acknowledgments

I'd like to thank the hugely professional Quadrille team, Sarah Lavelle, Helen Lewis and Liz Boyd; my excellent editor Jinny Johnson and talented designer Gemma Wilson; the late, great Ed Victor, my agent; my invaluable life-boss Mary Greenham; and Nic Corke of the Nic Corke Gallery in Liverpool, who took the huge risk of mounting my first solo show in the summer of 2017.

PICTURE CREDITS

The images used within this book are the copyright of the author, unless stated otherwise. The publisher would like to thank the following artists, photographers, agencies, galleries and organisations for their kind permission to reproduce the photographs in this book:

p2-3, p5 and p7 Andy Sewell; p23 Private Collection/James Goodman Gallery, New York, USA/ Bridgeman Images © The Estate of Jean-Michel Basquiat / ADAGP, Paris and DACS, London; p27 © Tate, London 2017; p29 2017©Photo Josse/Scala, Florence. © Successió Miró / ADAGP, Paris and DACS London 2017; p31 Courtesy of the artist and Simon Lee Gallery London/Hong Kong; p33 Private Collection, UK. Photograph courtesy of Richard Green Gallery, London; p34-35 David Messum Fine Art; p37 David Messum Fine Art; p45 © Frank Auerbach, courtesy Marlborough Fine Art; p47 National Galleries of Scotland, Edinburgh/Bridgeman Images; p49 National Galleries of Scotland, Edinburgh / Bridgeman Images; p51 Collection of the Duke of Devonshire, Chatsworth House, UK/© Devonshire Collection, Chatsworth/Reproduced by permission of Chatsworth Settlement Trustees/Bridgeman Images; p52 Mermaid, Jason Heeley; p54 ©2017. Photo Scala, Florence – courtesy of the Ministero Beni e Att. Culturali; p63 courtesy of the artist and Bernard Jacobson Gallery; p65 © Tate, London 2017 © The Estate of Patrick Heron. All rights reserved, DACS 2017; p69 Leeds Museums and Galleries (Leeds Art Galllery) U.K./ Bridgeman Images © Bridget Riley 2017. All rights reserved; p73 © Tate, London 2017. © The Barnett Newman Foundation, New York / DACS, London 2017; p76 Wonderland (oil, acrylic and glitter on canvas, 2004) © Fiona Rae. All rights reserved, DACS 2017; p77 Anthony and Cleopatra, 1983, Gillian Ayres OBE (b. 1930), purchased by Tate 1982. © Tate, London 2017; p97 Brooklyn Museum of Art, New York, USA/Gift of A. Augustus Healy/Bridgeman Images; p99 © 2017. Digital image, The Museum of Modern Art, New York/Scala, Florence. © Succession H. Matisse/DACS 2017; p101 © 2017. Digital image, The Museum of Modern Art, New York/Scala, Florence © Robert Rauschenberg Foundation/DACS, London/VAGA, New York; p103 © 2017. Photo, The Philadelphia Museum of Art/Art Resource/Scala, Florence © Robert Rauschenberg Foundation/DACS, London/ VAGA, New York; p113 © Jake and Dinos Chapman. Courtesy of the Saatchi Gallery, London; p115 © Michael Craig-Martin. Courtesy the artist and Gagosian. Photo: Mike Bruce; p116 Ross Armstrong; p117 © Tate, London 2017; p120 bpk/Sprengel Museum Hannover/Ernst Schwitters © DACS 2017; p121 © 2017. White Images/Scala, Florence © DACS 2017; p127 copyright the artist, courtesy Sadie Coles HQ, London; p129 © Anselm Kiefer. © Tate, London 2017; p131 © Jason Martin; Courtesy Lisson Gallery. Photography: Jack Hems; p133 © Adrian Hemming.

Andrew Marr's paintings photographed by A C Cooper.

The publisher has made every effort to trace the copyright holders. We apologise in advance for any unintentional omissions and would be pleased to insert the appropriate acknowledgement in any subsequent edition.